THIS LAND IS YOUR LAND

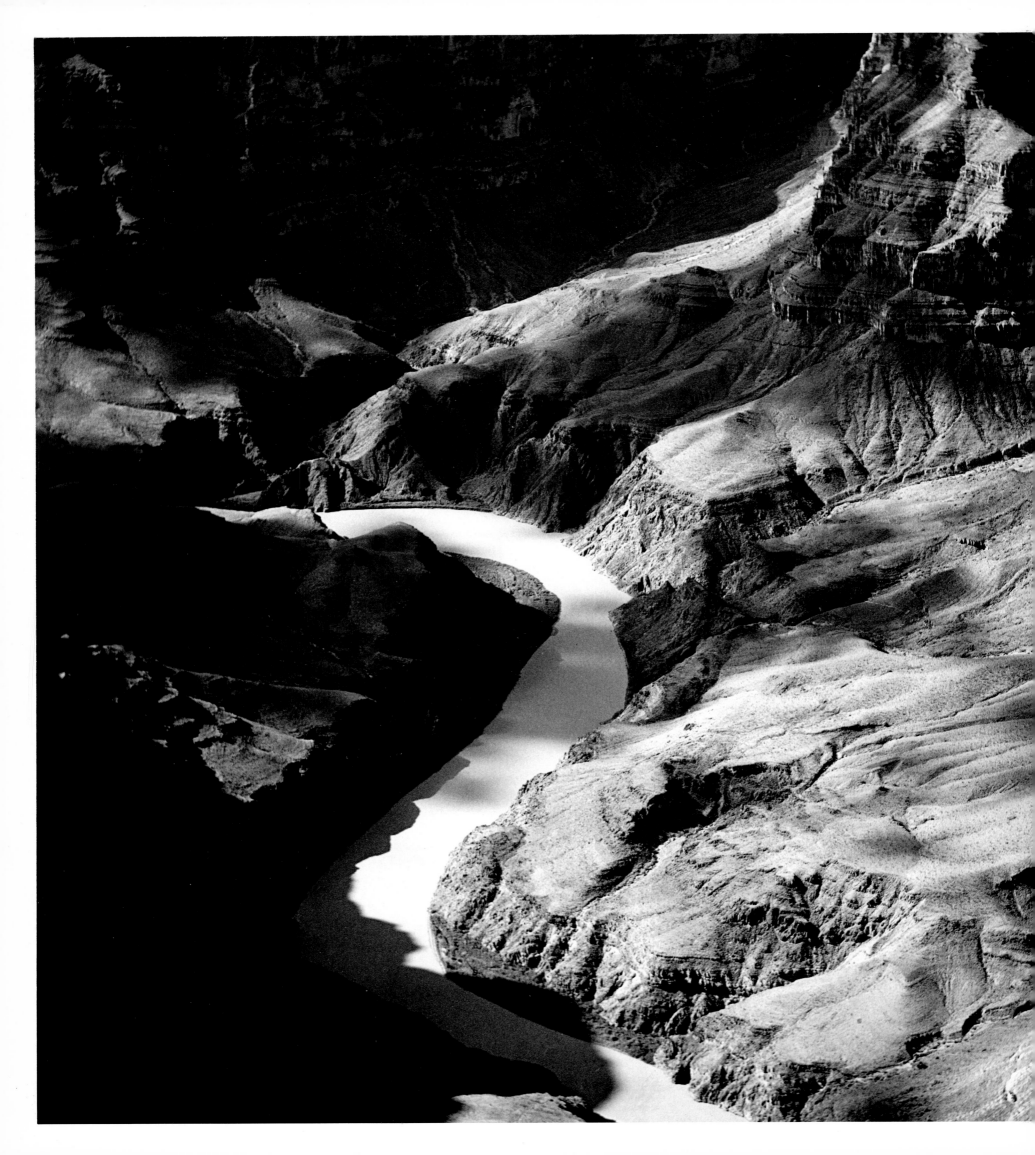

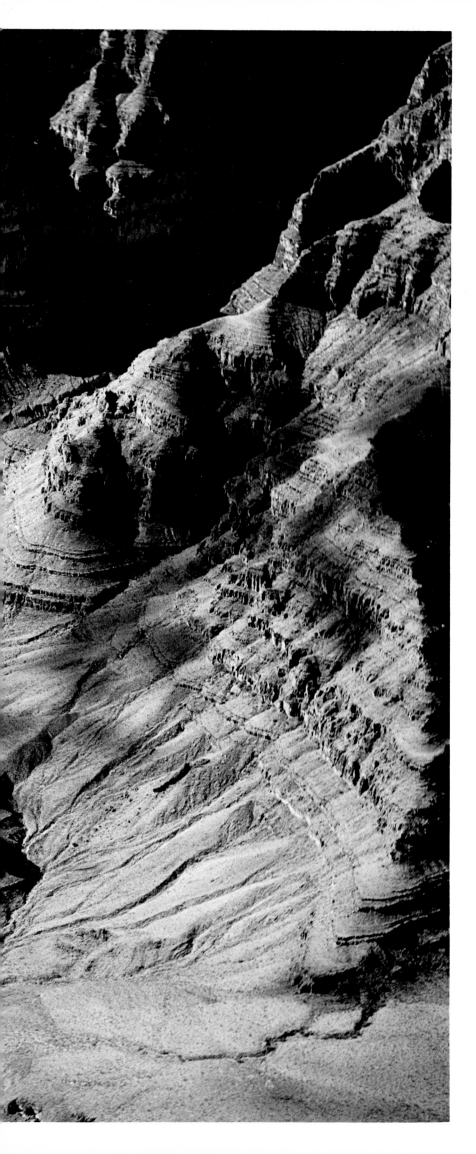

THIS LAND IS YOUR LAND
PHOTOGRAPHS BY MARILYN BRIDGES
Across America By Air

ESSAY BY WILLIAM LEAST HEAT-MOON

APERTURE

Grand Canyon, Arizona, 1991

To those who tread lightly on the earth.

The NORTHEAST

The SOUTH

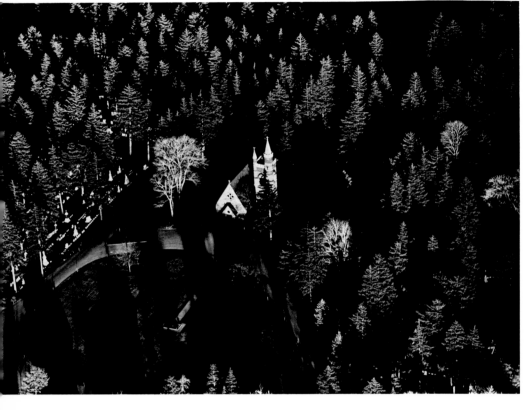

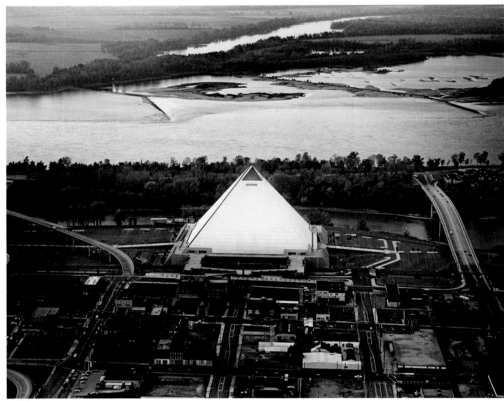

Church in Pines, Monroe County, New York, 1981

10–35

Memphis Pyramid (Overview with Mississippi River), Tennessee, 1994

36–59

The **MIDWEST**

The **WEST**

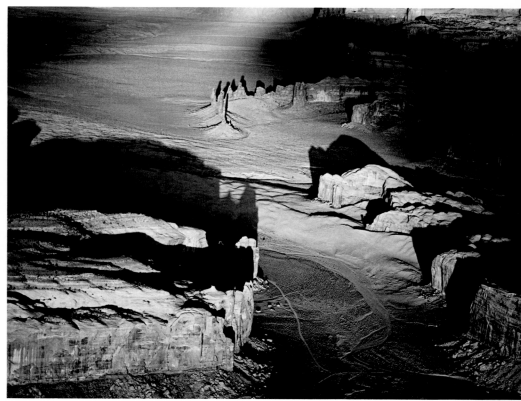

Praying Hands, Oral Roberts University, Tulsa, Oklahoma, 1991

60-75

Journey, Monument Valley, Arizona/Utah, 1983

76-103

"The airplane has unveiled for us the true face of the earth…. And then, only, from the height of our rectilinear trajectories,
do we discover the essential foundation, the fundament of rock and sand and salt in which here and there and from time to time life like a
little moss in the crevices of ruins has risked its precarious existence."

—*Antoine de Saint-Exupéry*

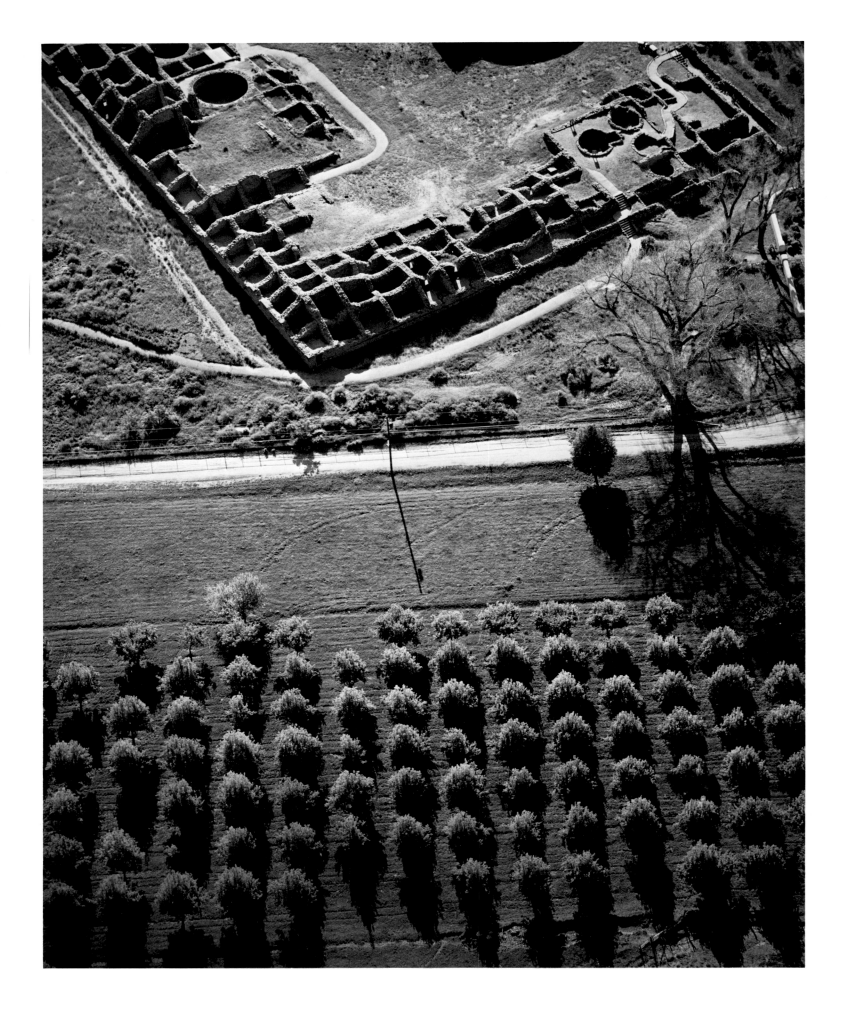

Aztec Ruins and Orchard, New Mexico, 1983

SHADOWS ON THE AMERICAN LANDSCAPE:

The Photography of Marilyn Bridges

You can see in an early Marilyn Bridges photograph of a church in Monroe County, New York, how a broad but low sprawling of sunlight stands the pines upright and thrusts the steeple and gravestones into an apparent third dimension. Bridges told me she had to learn to look at the tops of things just to recognize them and that nothing is more revealing than their shadows, their absences. Without the long shadows that reveal players on the field and a game in progress, her picture of the baseball diamond in Allens Creek, New York, would be merely lines marked into soil; the silhouettes change the photograph from an abstract to a stop-action picture. She says, "Shadows give away the secrets of what's down there." For me, there is no other way to understand her photography without comprehending her continual hunt for secrets and mysteries. For her, the face of the earth is one glyph after another shrouded in shadows to be exposed and interpreted.

Indeed, her hallmark is shadow, the sharp delineation of absent light. One could easily turn the etymology of *photograph* on its ear and call a Bridges aerial landscape an *umbragraph,* where darkness explains things —or at least exposes them—far more comprehensively than does light. Her use of shadow is so telling, so refined (and this is remarkable given the speed of her flying "tripod" and the buffeting it takes from air currents) that she can capture from four hundred feet above a picture of, incredibly, even the shadows cast by monofilament fishing lines at the Outer Banks of North Carolina.

Marilyn says, "For a while I was totally fixated on shadows. I saw them not just as the absence of light but as the absence of life and energy. They were the opposite of sunlight. They were mysterious, scary, and I think they touched my notions of dis-

appearance and death. Much of my early work was of isolated farmhouses buried in or encircled by shadows, lonely places, forbidding, and I think that fascination came from childhood days at my grandparents' farmhouse, a place I found to be strange and rather frightening, almost haunting. The darkness of those halls keeps coming back to me."

It is no surprise for us to discover childhood memories—especially dark ones—informing an artist's work, and so, in this sense, one can see her own history of darkness itself lighting the

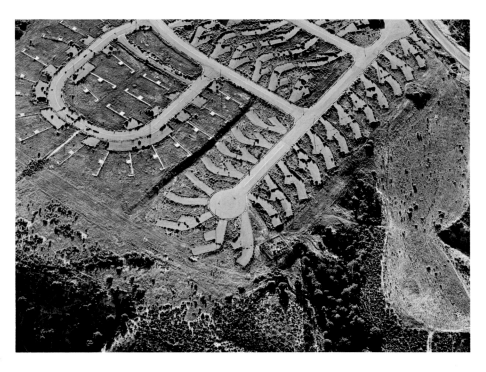

way to Bridges's unique aerial vision. She sometimes paraphrases Anne Morrow Lindbergh (perhaps not coincidentally another artist-pilot): "Where your pain is, there is your work."

But, as Bridges has matured as an artist, as her comprehension and techniques have changed, she now says, "I no longer see shadows merely as negative space or as absences. Often they're more important than the thing casting them. They can be more beautiful than the solid object itself, and always more haunting."

Abandoned Housing Development, Parachute, Colorado, 1992

When I look at her early photographs, I see how shadows seem to isolate central objects—the equestrian in Mendon, New York—and make them look lonely in an empty land. (The photographer herself possesses a powerful aura of aloneness while still being warmly human; I have the feeling that there are reaches—shadows, perhaps—in her that no one ever touches.) But her more recent work, it seems to me, is beginning to move from a certain happenstance of shadow patterns to a search for dark designs that stretch out to interconnect and reveal the ways life links with and

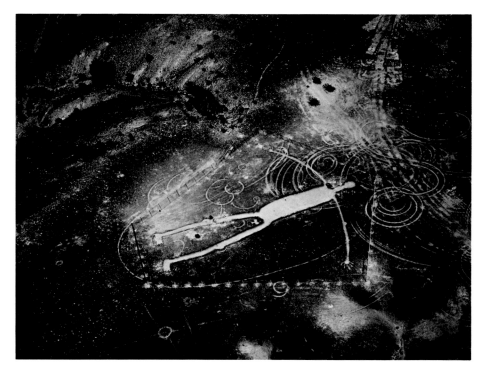

depends upon other life, especially through historic time. There's a movement away from a dominating theme of isolation to one far more holistic, if you will. Notice in certain later photographs—the big metal pyramid that so emanates technological power without any sacred or mystical overtones in Memphis, Tennessee, for example—that she will use deep tones to give almost a texture to a murky day. A flat, nearly shadowless light seems to connect the disparate elements below into a whole while still carrying a forbidding sense of something both lacking *and* darkly looming.

Bridges has always overcome the difficult task of making aerial photographs look like something other than picture maps—a problem compounded by her fascination with graphic outlines—by flying low and letting shadows dominate. But now she is not afraid of taking on light in almost any of its permutations, as long as she can achieve a perspective that draws us downward, and gives us a dreamy desire to parachute into the scene to confront the mystery. Of this "intimacy of altitude," she says, "In my early work, I wanted to look into people's lives, a strange thing for someone photographing from a plane. Critics have described this distance from the ground as that of an angel or a witch, but I feel more like a spy, especially when I have a view of their backyards, their swimming pools, their lives behind fences and hedges. It's a view not meant to be shared with an outsider."

Her desire to discover and read the shadows and forms below her wings continues (sometimes with a humorous directness that gets spelled out, as in the "IF YOU SMOKE" billboard that shows up as if a disease itself in the wretchedly corrupted landscape near New York City) to more subtle messages like the school bus half-buried in a Hawaiian flow of lava as if the earth wished to cleanse itself of human intrusion, or the Halloween-like fright mask glaring at us from the over-cultivated, over-fertilized, over-fumigated field in Oklahoma. Bridges says, "Sometimes the earth seems to look back." I like this reversal, this topsy-turvy twist of our long fascination of looking up into the night sky to search for patterns and figures among the stars that might give some poetic meaning to our lives below, as well as that inevitable sensation that the stars themselves are looking down *at us*. Surely, though, we can learn more about our fate by studying the tracks we

Ha-ak, Blythe, California, 1981

8

are leaving under us than by trying to connect the dots of light above.

Marilyn Bridges is edging deeper into the mystery of earth signs as she moves more and more into social involvement. The terrestrial markings she photographs now seem to carry a message of a threatened culture; the results of her work suggest a civilization in deep disregard of massive and impending consequences, and the irony is that so many of these newer photographs seem to sparkle in the warm benevolence of balmy sunlight: a Colorado River so proliferated with boats it looks like a Los Angeles freeway, a zigzag strip of concrete (like a thunderbolt) covering something—she has not been able to learn what—at the Hanford nuclear waste site in Washington state (p. 78); the frightening tracery left on the surface of the Mojave desert from military exercises, scars that will take a century and more to erase; the abandoned Parachute, Colorado, housing development that lies in wait like a poisonous centipede.

So there comes now into her work a looming of shadows from a supposedly enlightened civilization which she occasionally counterpoints with a harmoniously shaped earthscape from another time when humankind yet honored the face of the land itself. Her view is still a haunted one, but now the haunting comes from the earth signs left us a thousand years ago: the bear effigy lurking in the trees just at the edge of the Iowa town; the long-limbed giant prone on the Mojave, cut by off-road vehicles and caged in chainlink. These ancient earth signs, so often built on topographic eminences something like aerial sites, bespeak power because they have endured so long, *and* because their makers created them to honor the sacred in their lives.

Marilyn Bridges's airborne camera—at the very least—leaves us a visual record of these resonant places before we obliterate them entirely. But further, the possibilities in her art can carry to us something even more significant than mere visual preservation documents. What she has recorded for us, these earthen images, if we will respond to them, call us as the millennium approaches to reinvent meanings for them, to create our own new interpretations, to reuse these figures, to reanimate them so that they might remind us to check our arrogances and

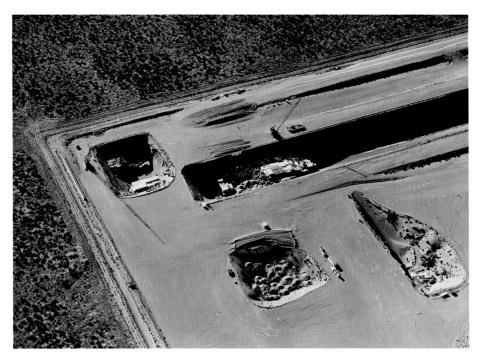

to redefine our sense of the sacred. They can help us attune our lives—as they surely did for their makers—to the land which is our source. The shadows in these earth signs, both old and new, are there for us to read if we can only rise high enough to earn a new perspective.

William Least Heat-Moon
Columbia, Missouri

Nuclear Waste Dump, Hanford Nuclear Site, Washington, 1992

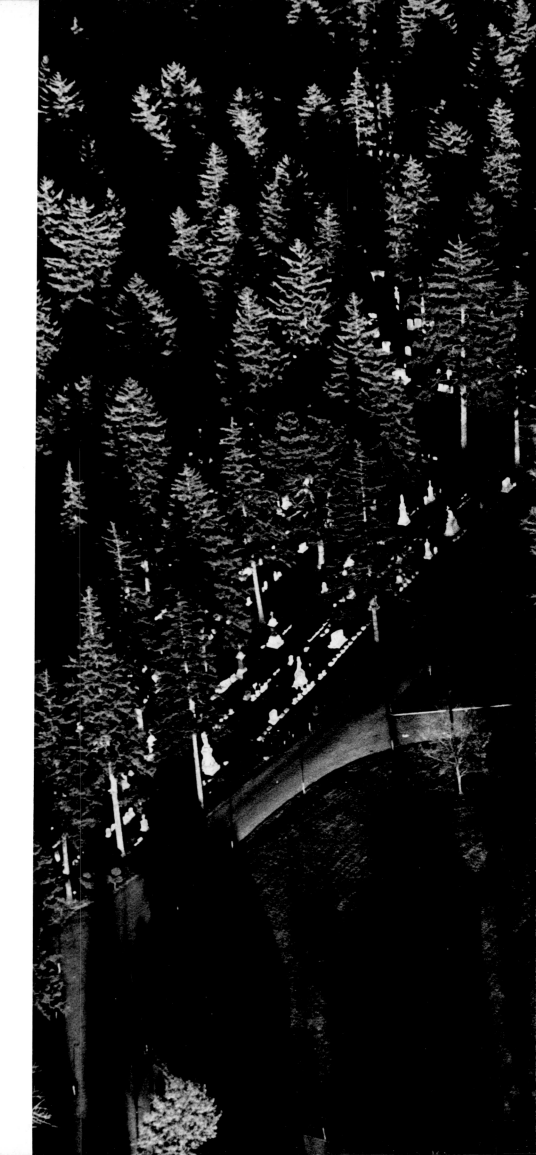

The NORTHEAST

My roots are in the Northeast. It is here that I am reminded of what I have loved and what I have grieved for in childhood and womanhood. So there is both pain and delight. This is familiar territory. It speaks to me of stability and tradition. Of foreign roots transplanted in virgin soil. Despite excesses in development there still seems to be the semblance of balance in the Northeast. Perhaps this is because Nature has been subdued. Or maybe it means humankind and Nature can truly live together.

Church in Pines, Monroe County, New York, 1981

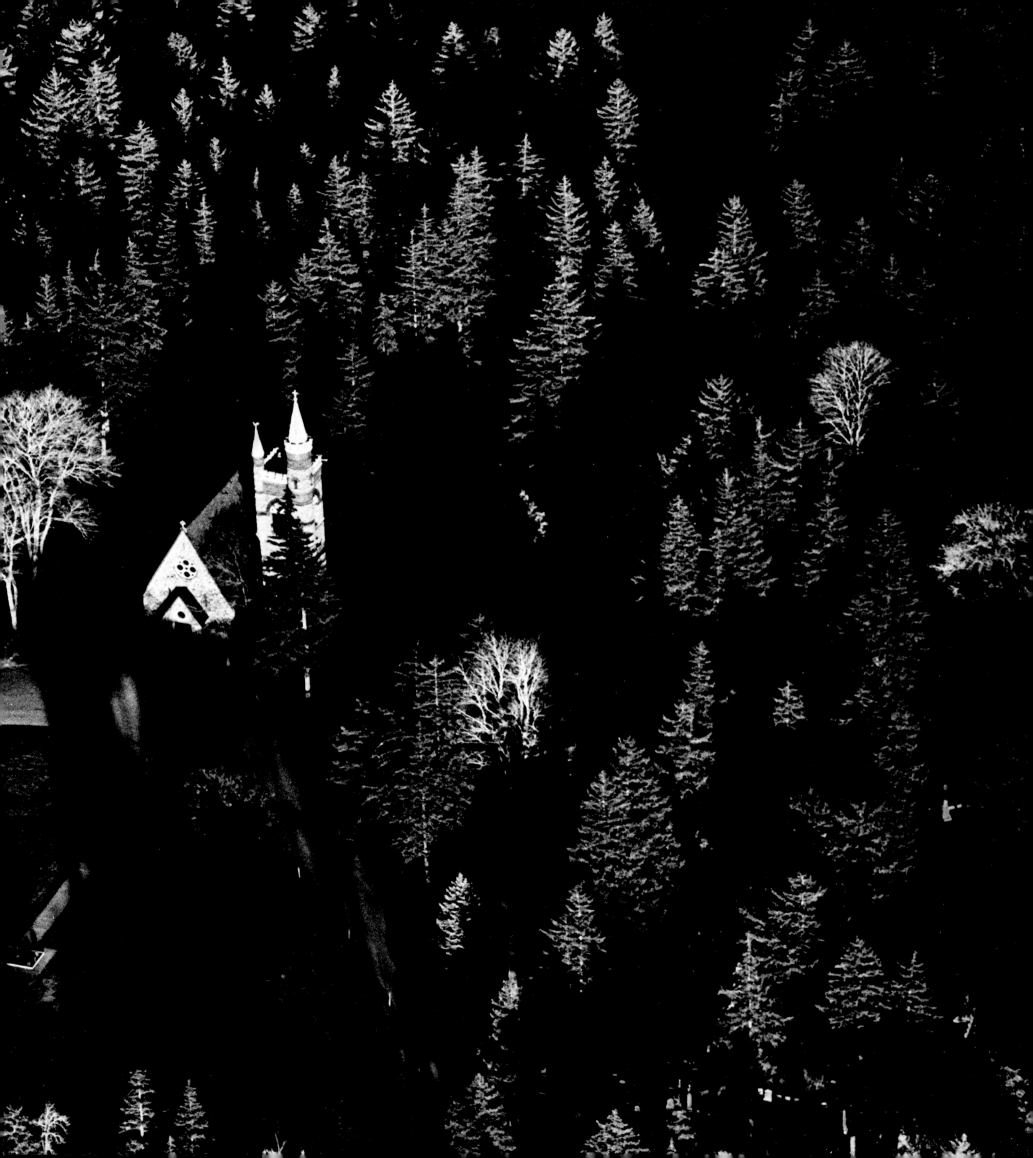

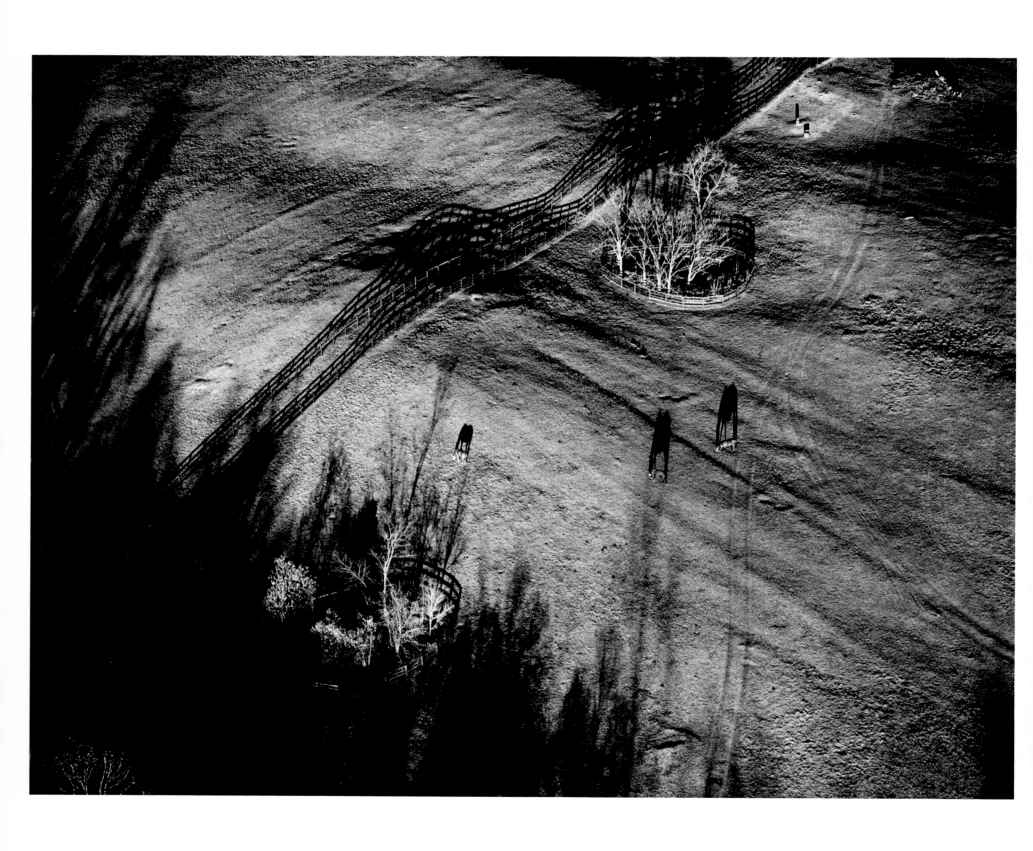

Horses Grazing, Cornwall, Vermont, 1984

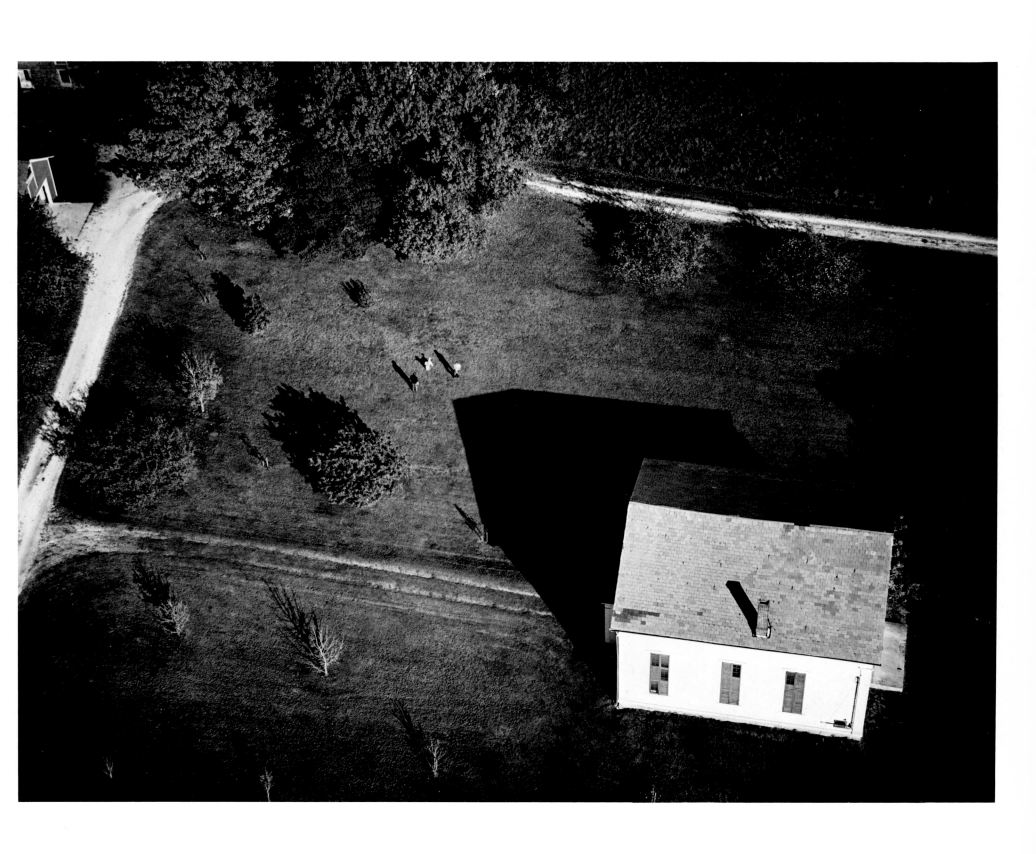

Tom, Ali, and Will—Standing Near Old Family Chapel, Beaver Brook Farm, West Cornwall, Vermont, 1984

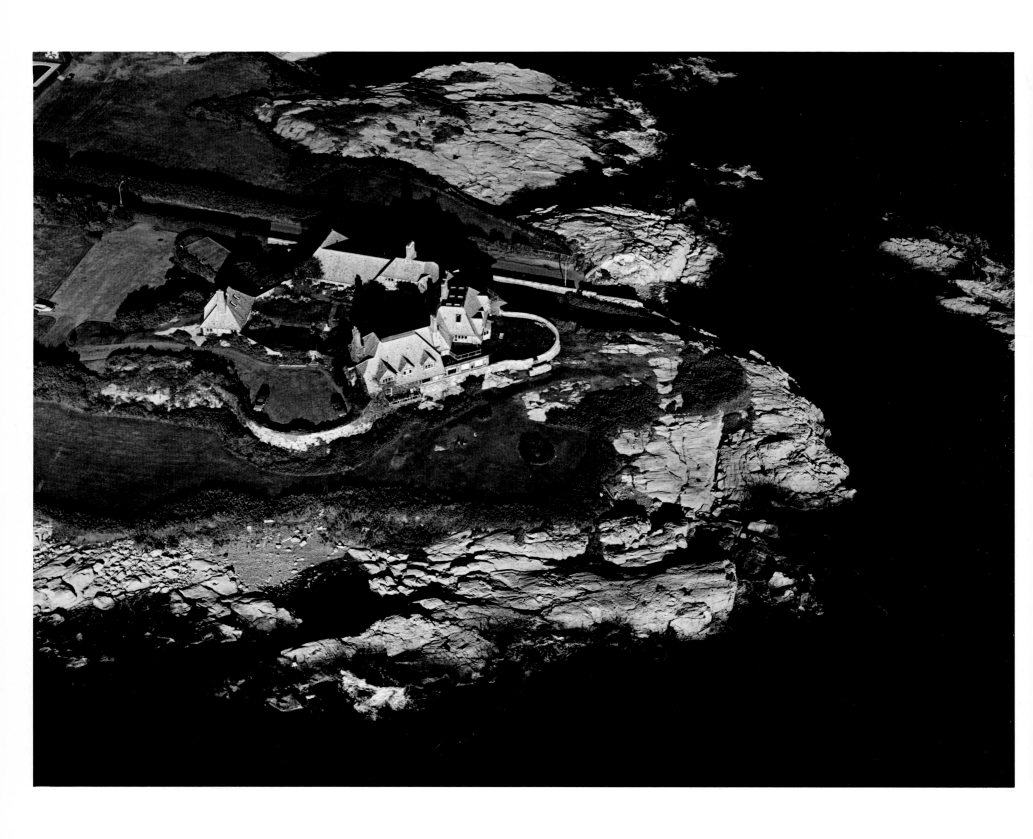

Newport, Rhode Island, 1995

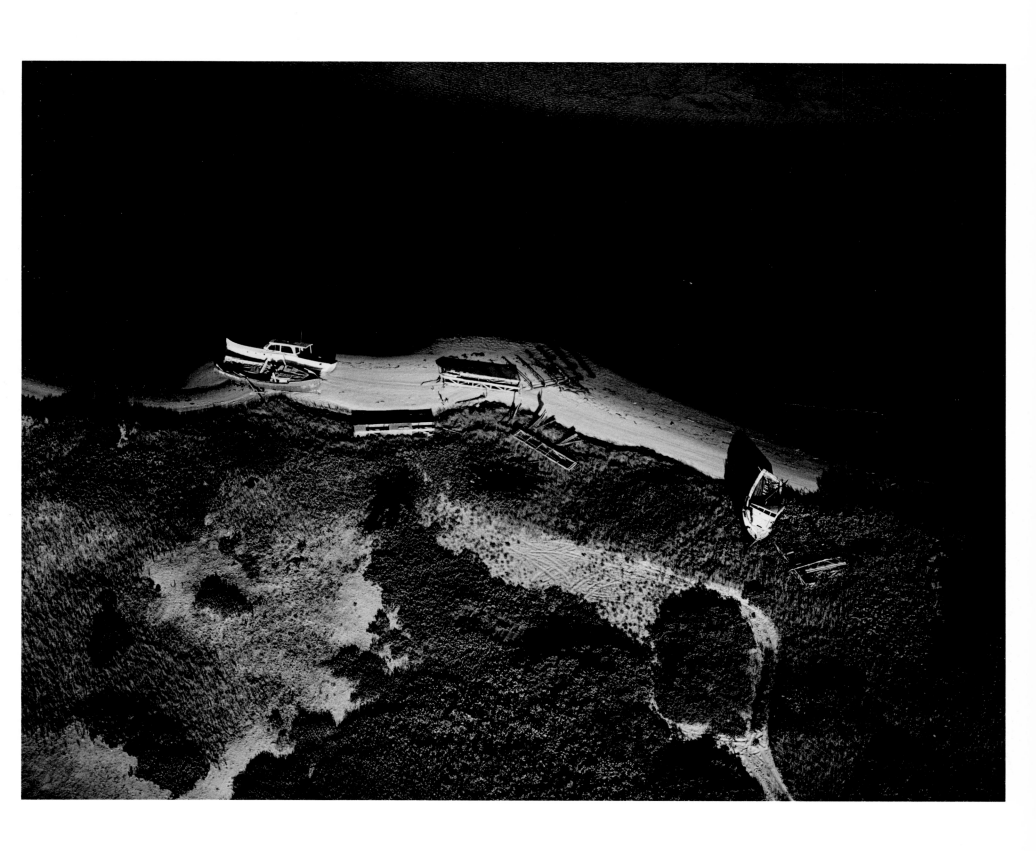

Boats on Shore, North Haven Island, Maine, 1992

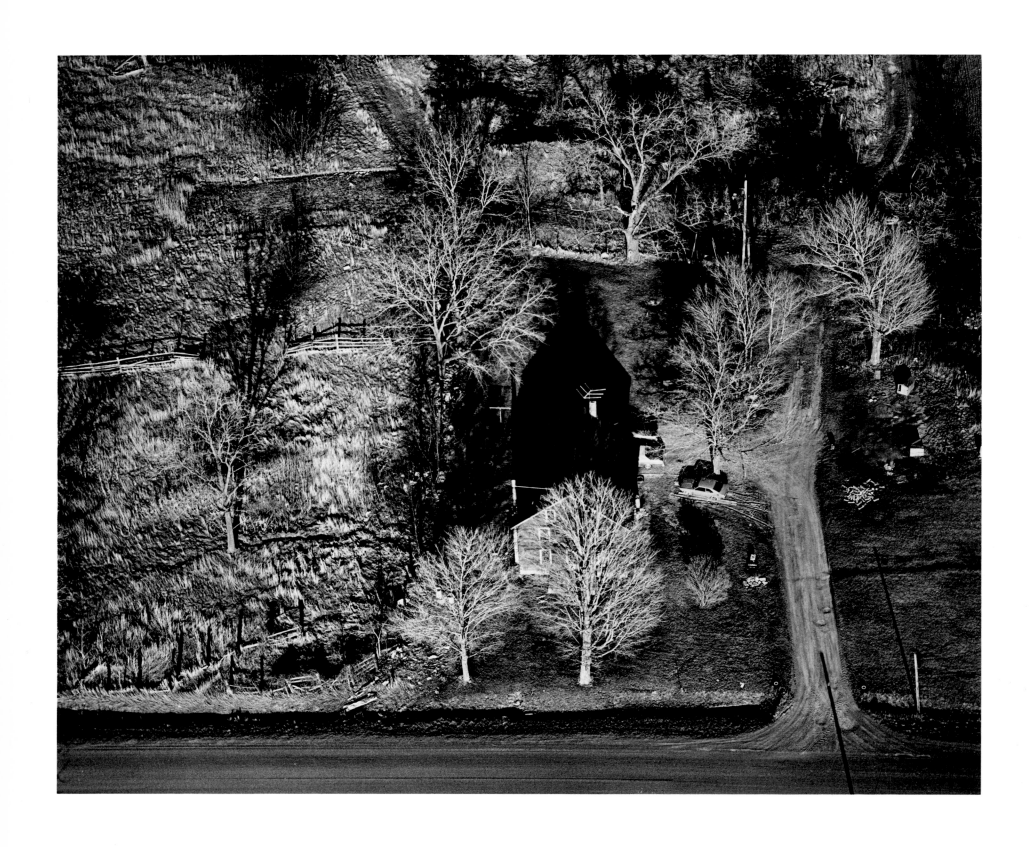

Farmhouse, Le Roy, New York, 1981

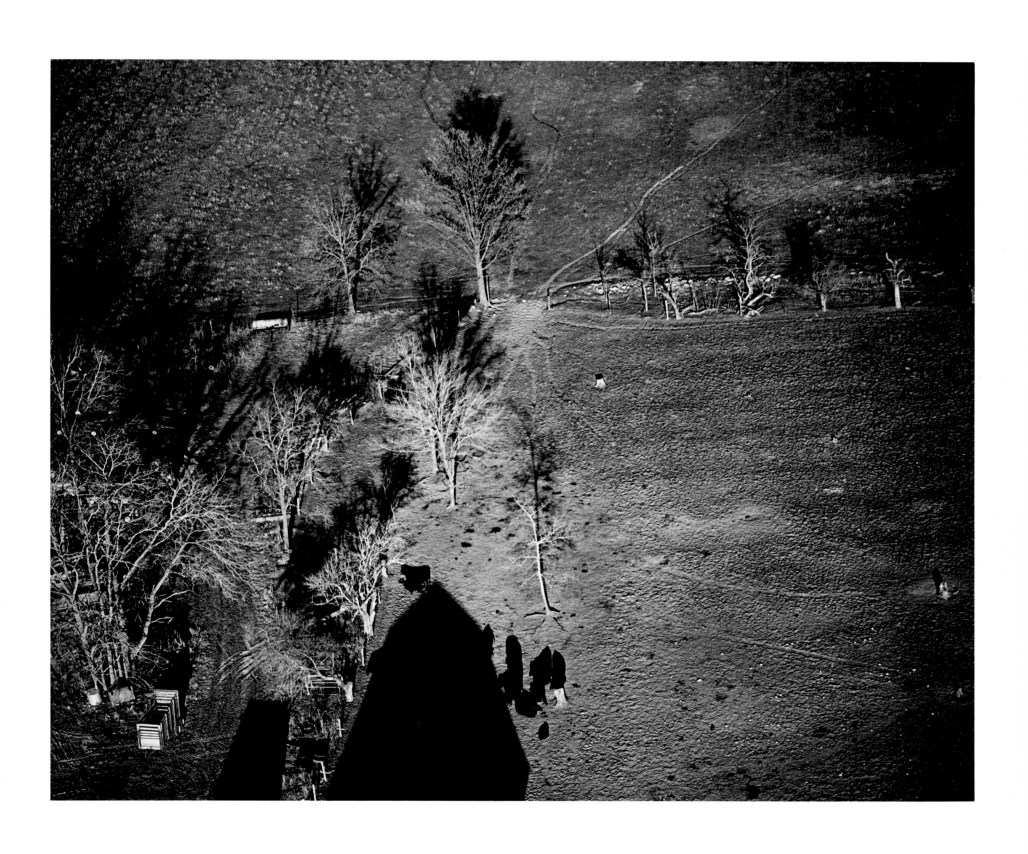

Barn Shadow, Le Roy, New York, 1981

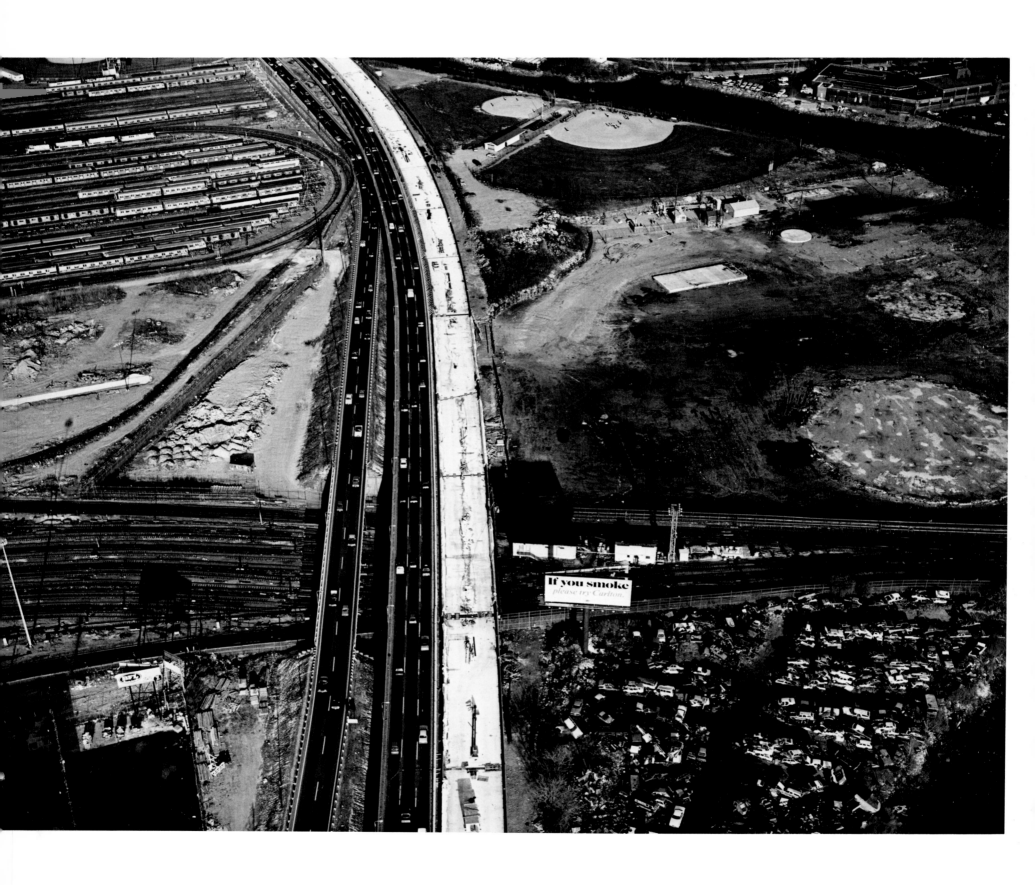

If You Smoke, New York City, 1985

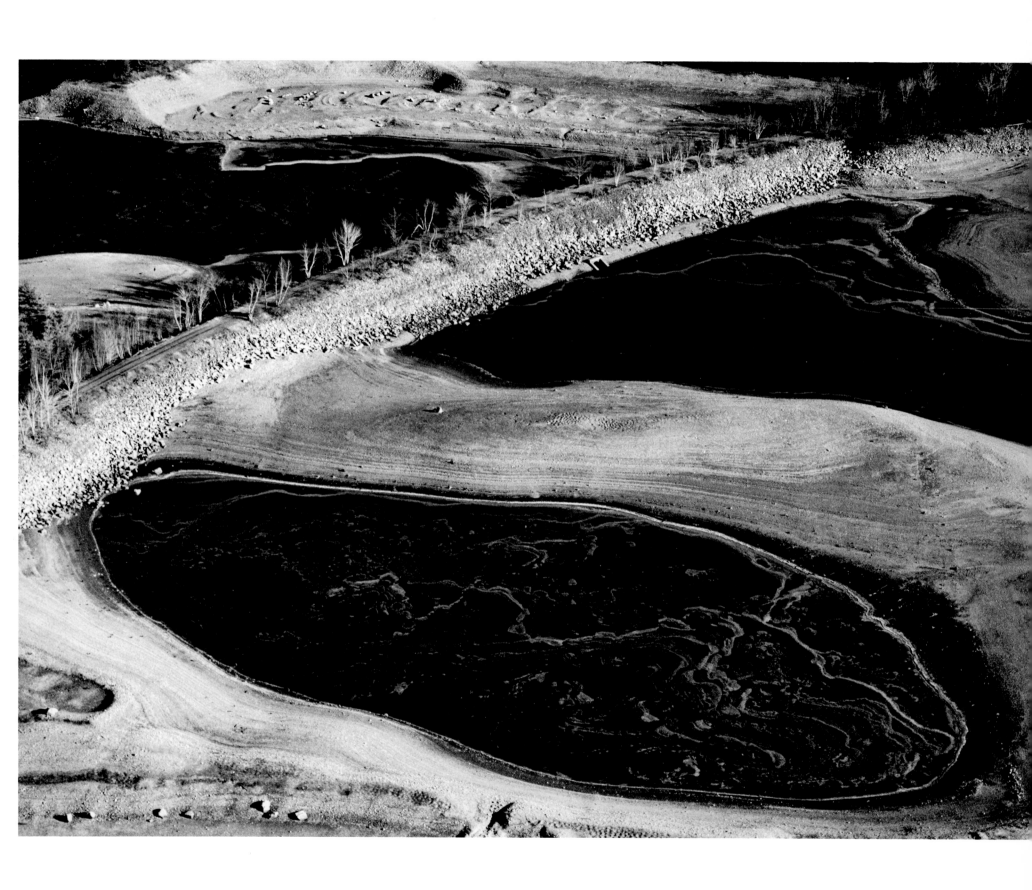

Wanaque Land Bridge, New Jersey, 1981

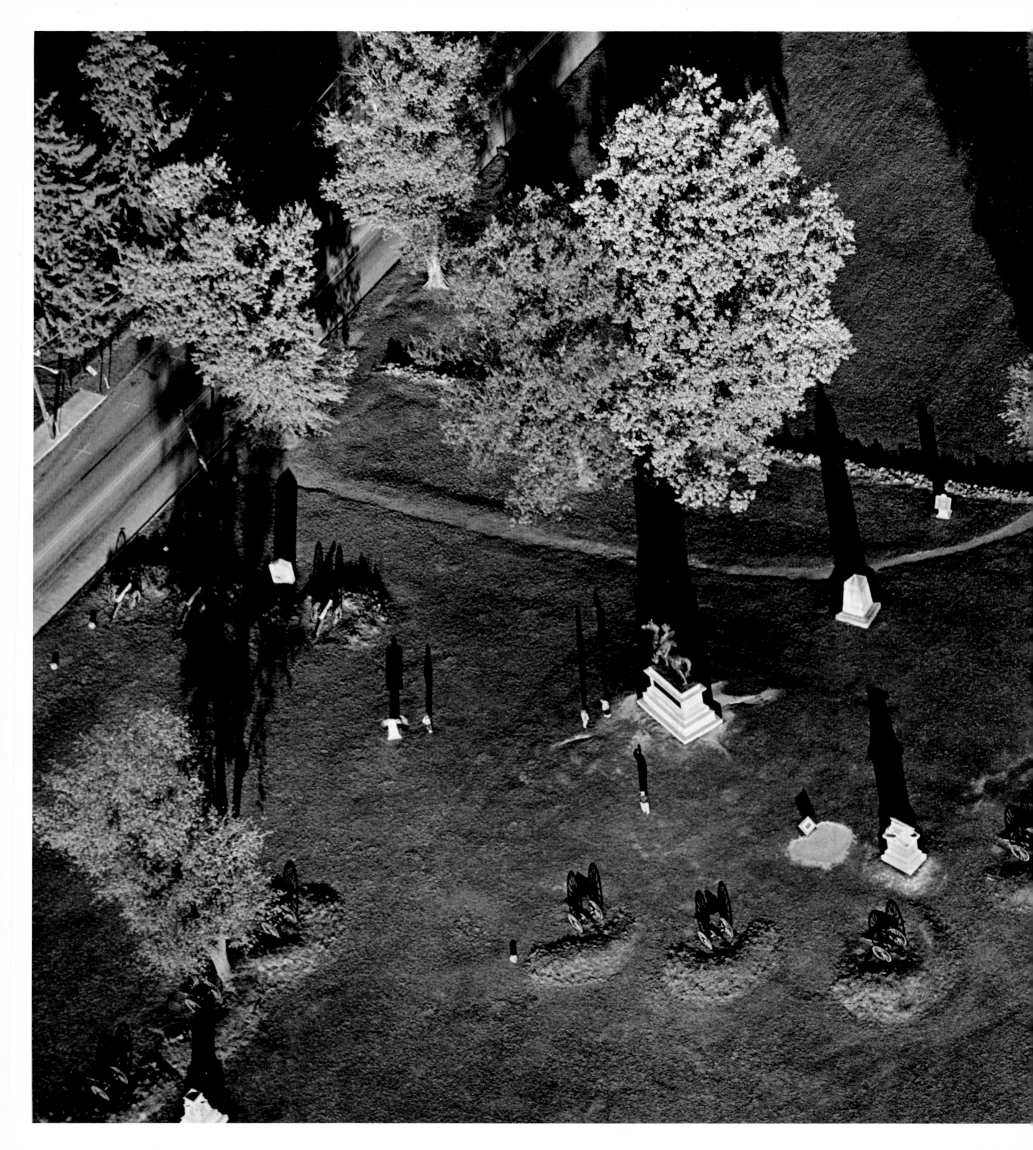

The General Winfield Scott Hancock Monument, Gettysburg, Pennsylvania, 1994

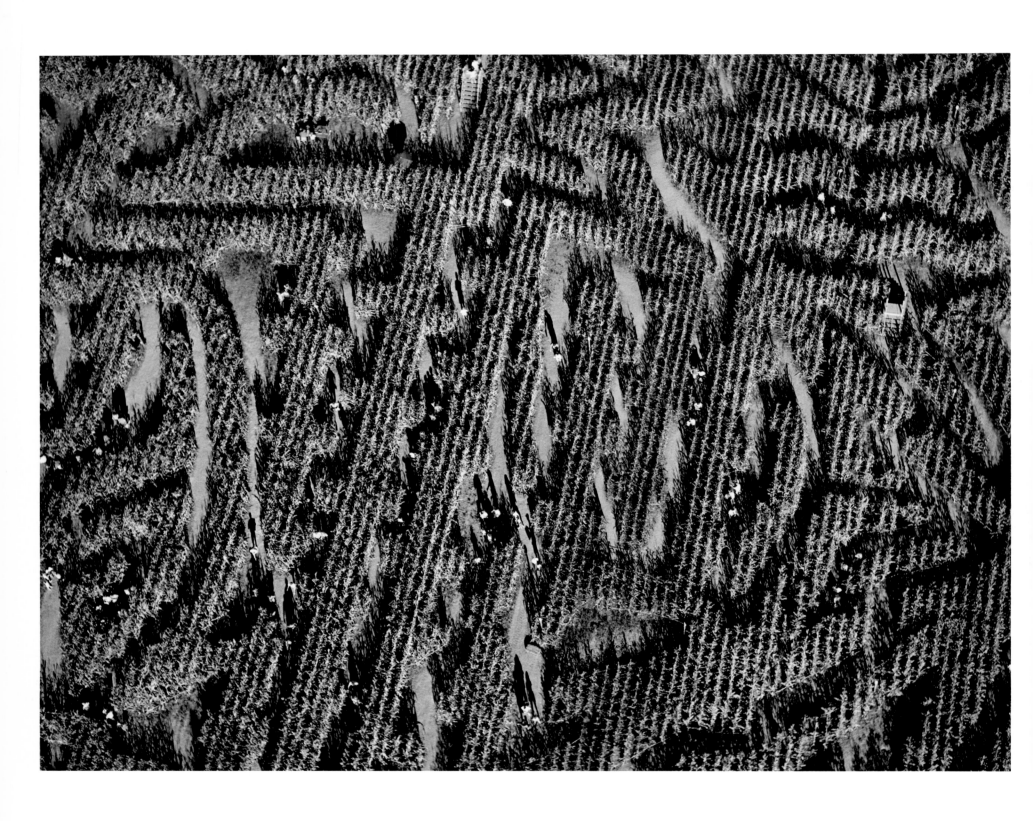

Amazing Maize Maze, Shippensburg, Pennsylvania, 1995

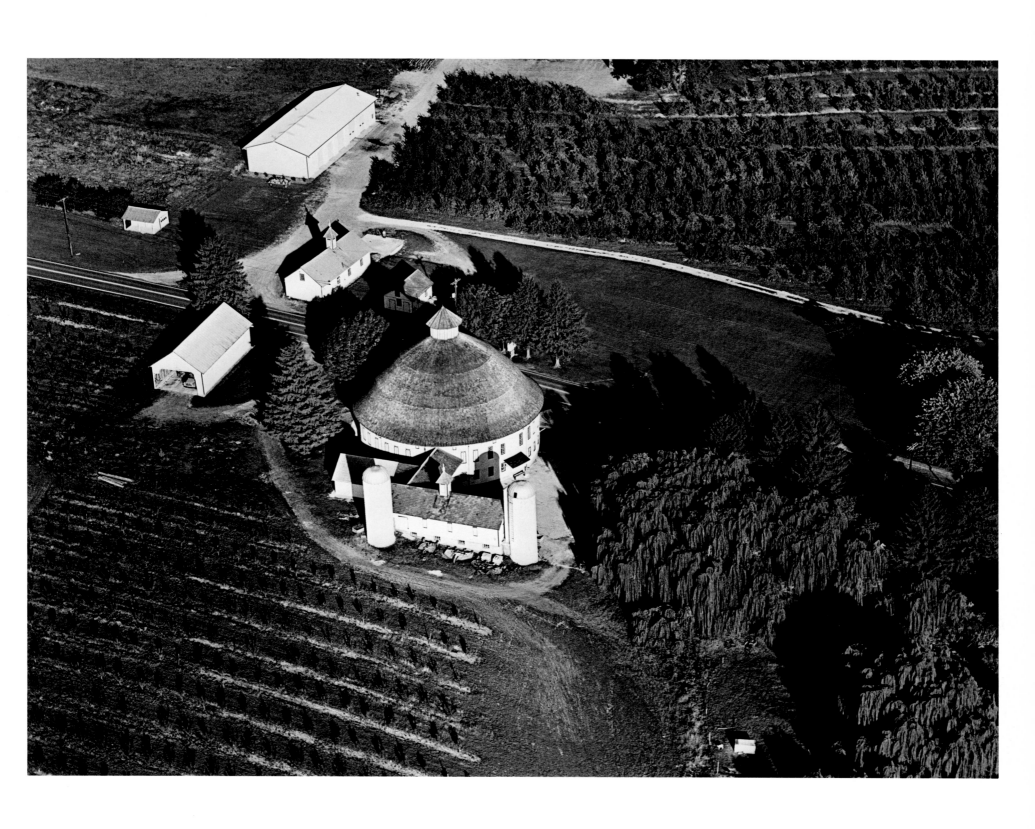

Round Barn, Adams County, Pennsylvania, 1994

Road, Avon, New York, 1981

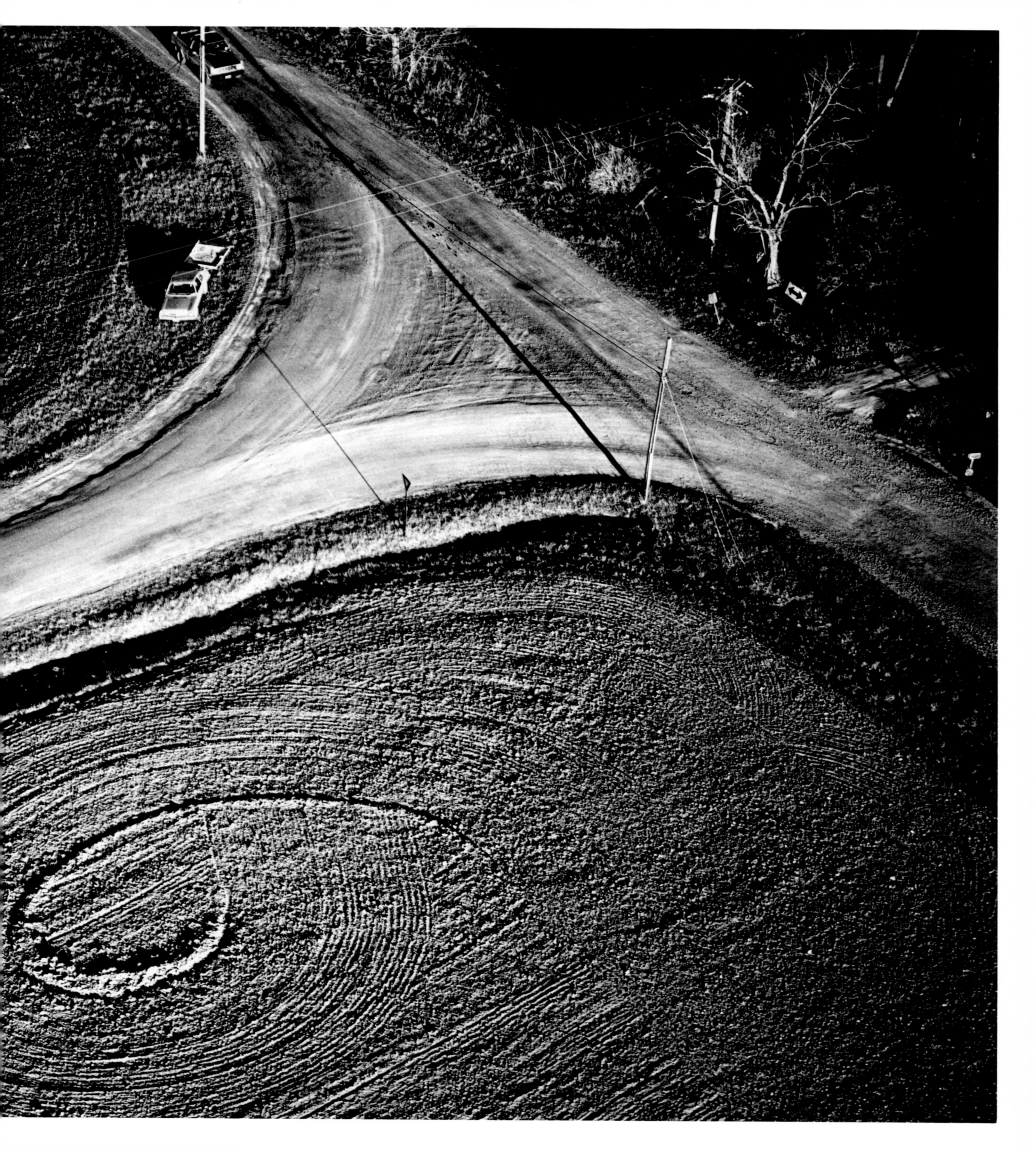

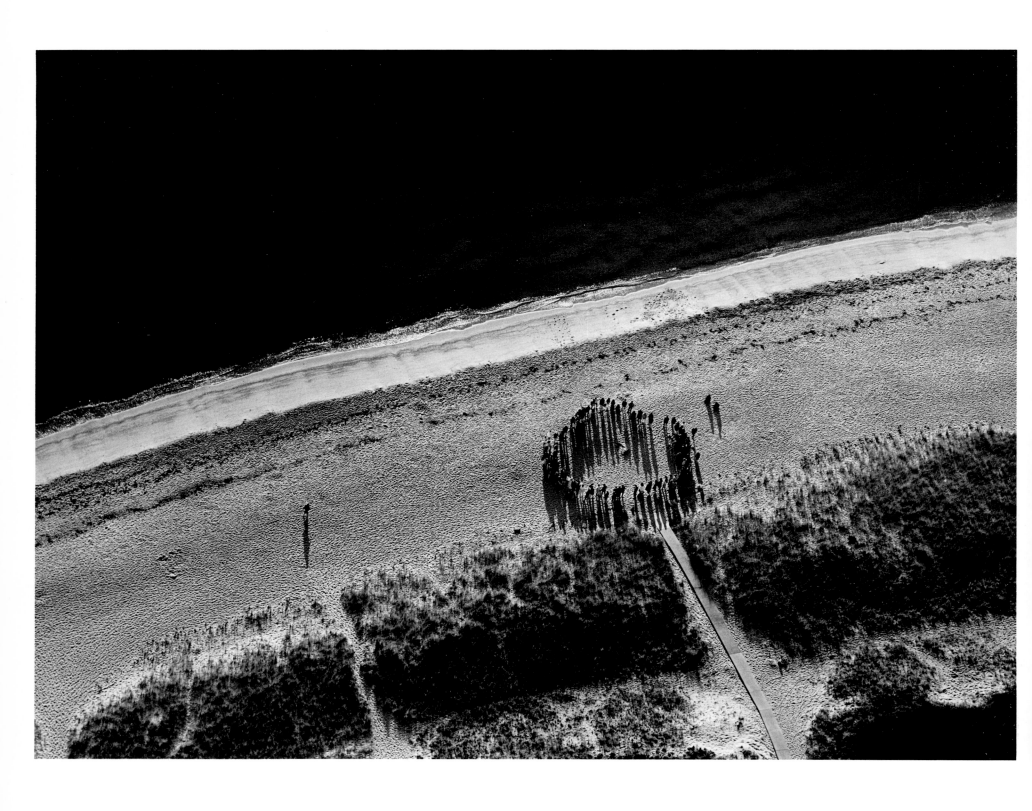

Funeral for a Friend, Martha's Vineyard, Massachusetts, 1994

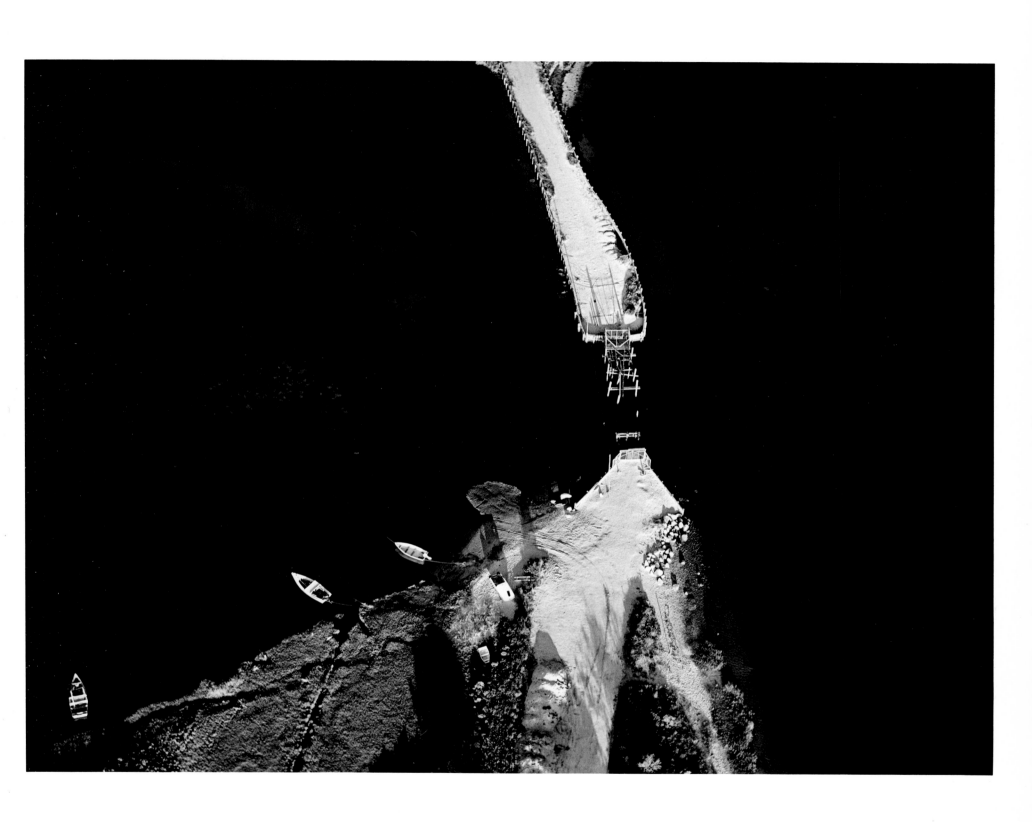

Dike Bridge, Chappaquiddick, Massachusetts, 1994

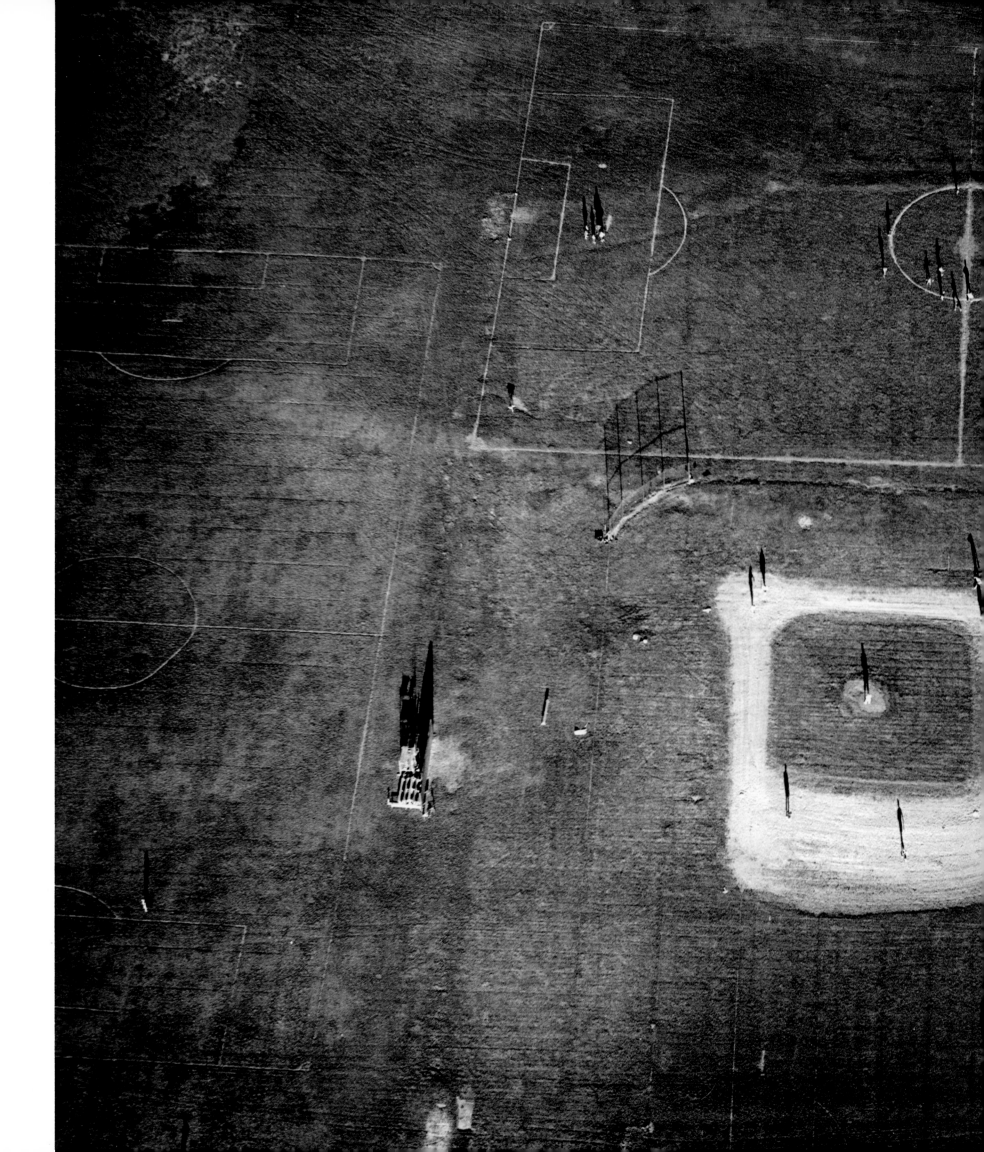

Playing Baseball, Allens Creek, New York, 1986

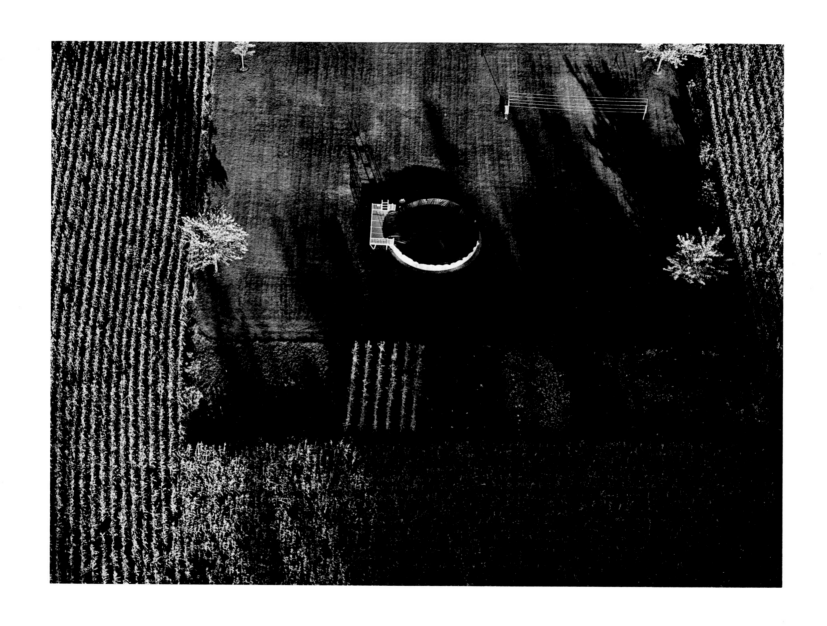

Yin Yang Pool, Caledonia, New York, 1981

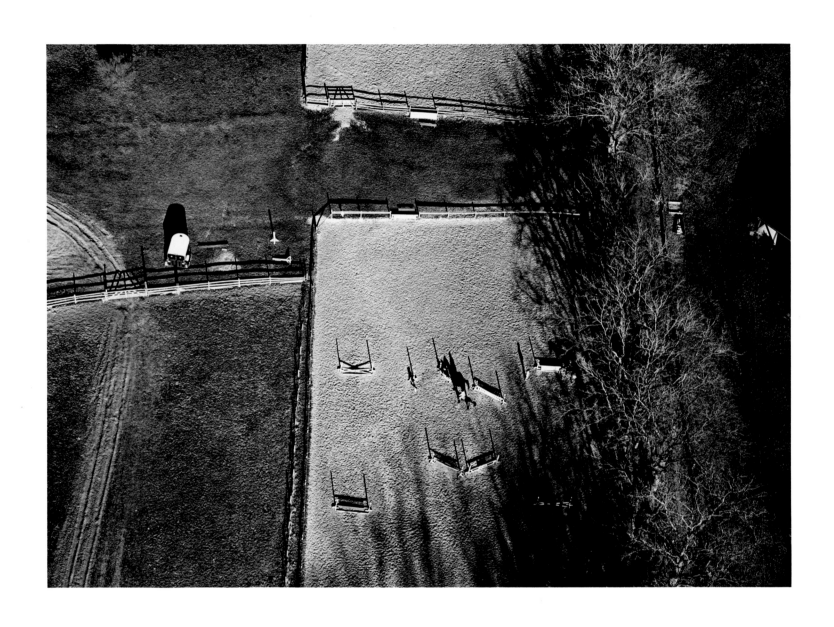

The Equestrian, Mendon, New York, 1986

Observatory, Webster, New York, 1981

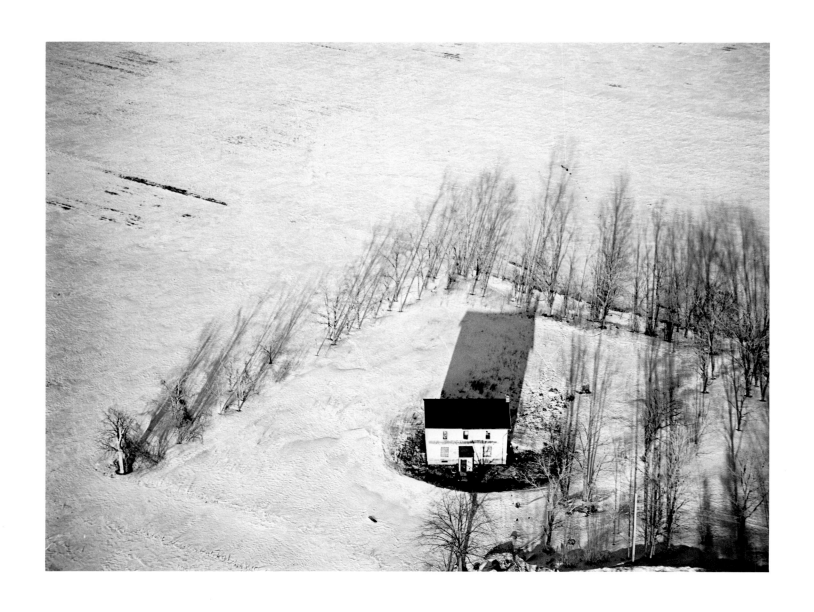

Lone White House in Snow, Scottsville, New York, 1982

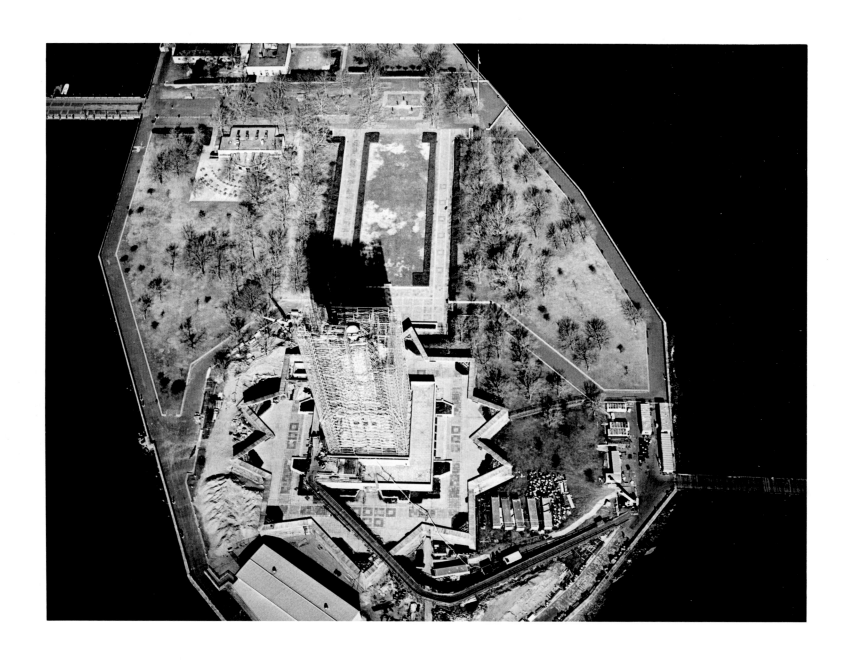

Above: *Statue of Liberty (Front), New York City, 1985*

Right: *Chrysler Building, New York City, 1988*

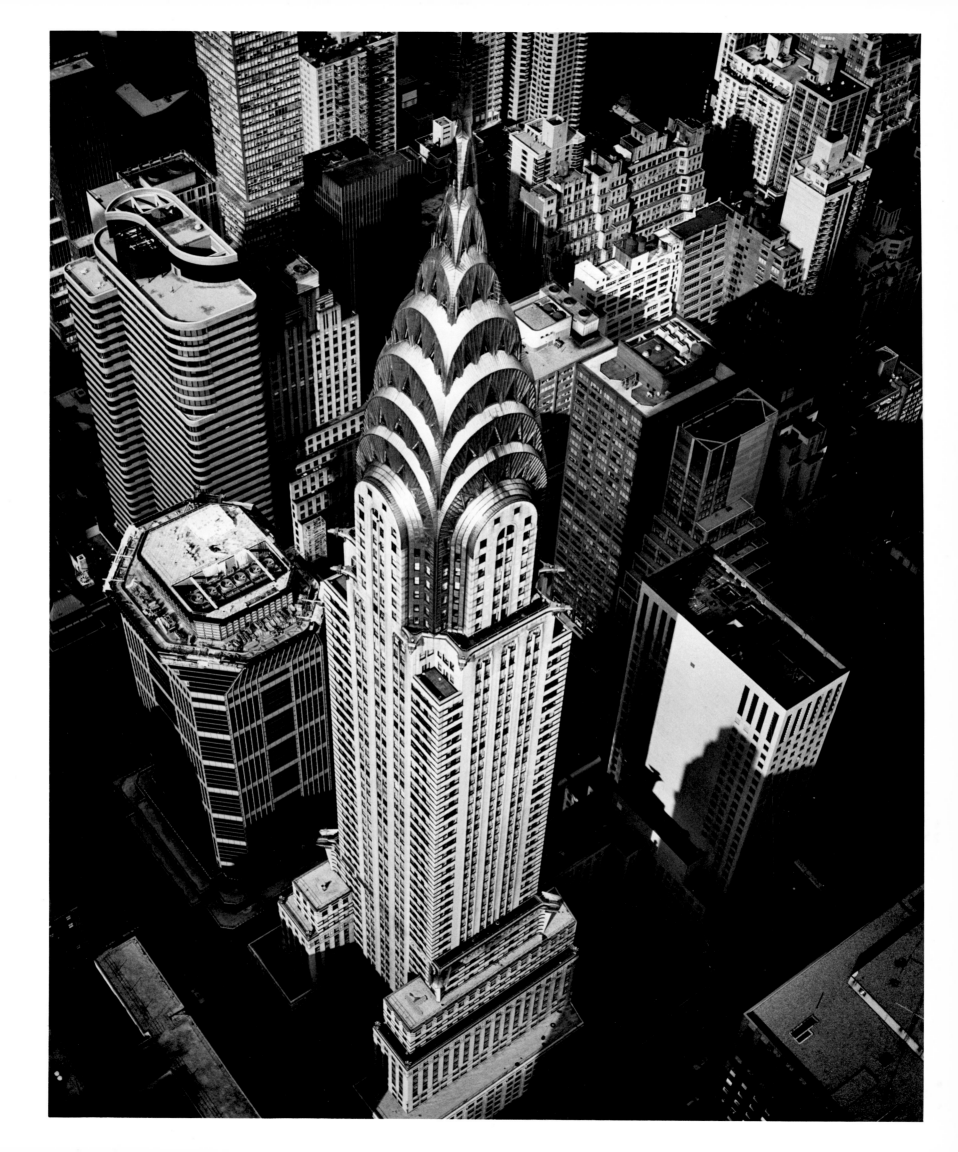

The SOUTH

Sometimes the landscape offers me a respite from reality. Witness the huge sphere that squats atop Epcot Center in Florida like an errant golf ball. Or a power plant in North Carolina that is magically transformed into a whimsical cloud-making machine. And what flight of fancy created Memphis's huge metallic pyramidal convention center on the shores of the Mississippi, a river locally dubbed the "American Nile"? Were city planners aware of the irony at hand? For while many of the Egyptian pyramids remain intact, the city's namesake, Memphis of antiquity, has long disappeared under layers of shifting sands.

Memphis Pyramid (Overview with Mississippi River), Tennessee, 1994

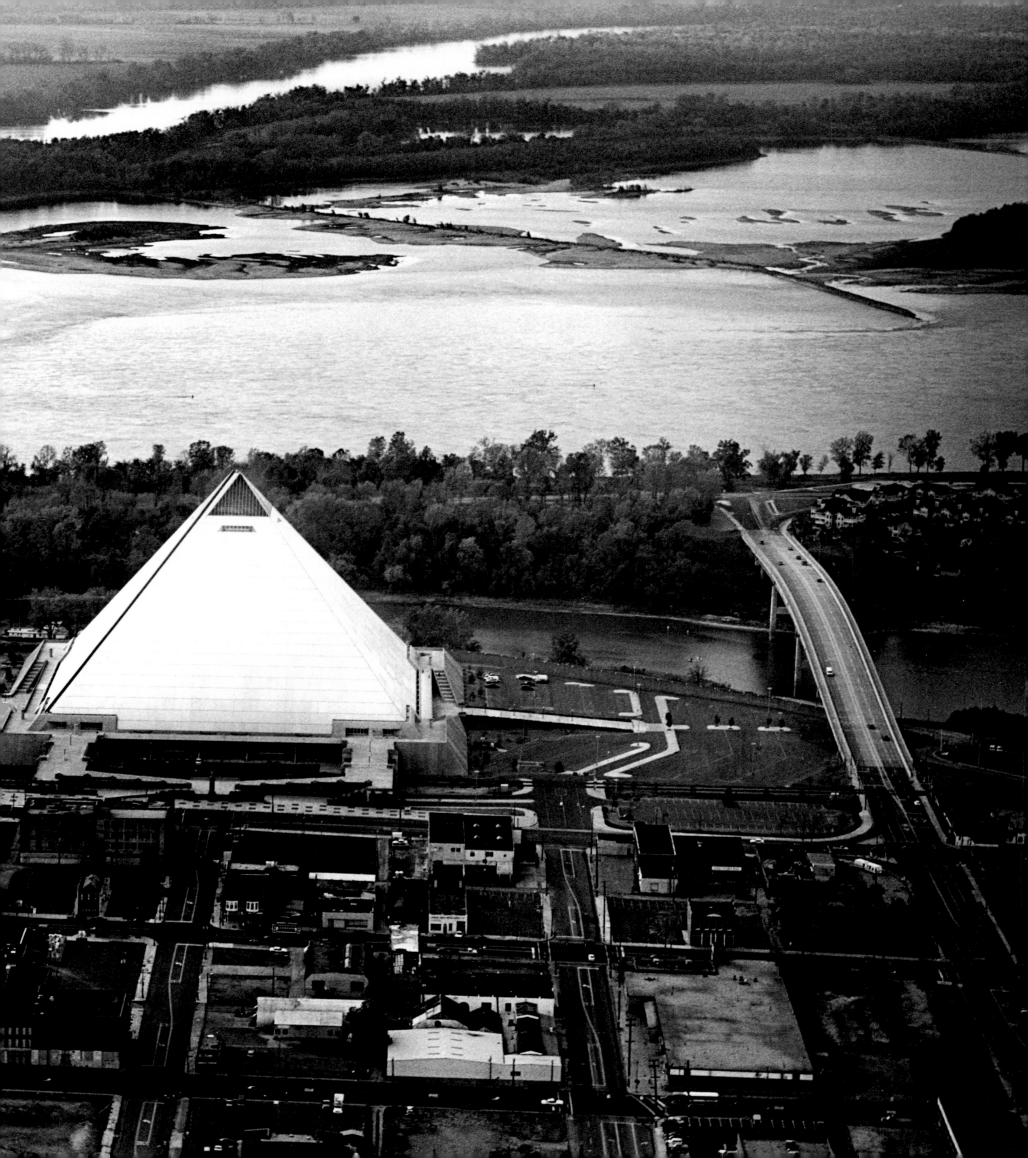

Power Plant, Pamlico Sound, North Carolina, 1993

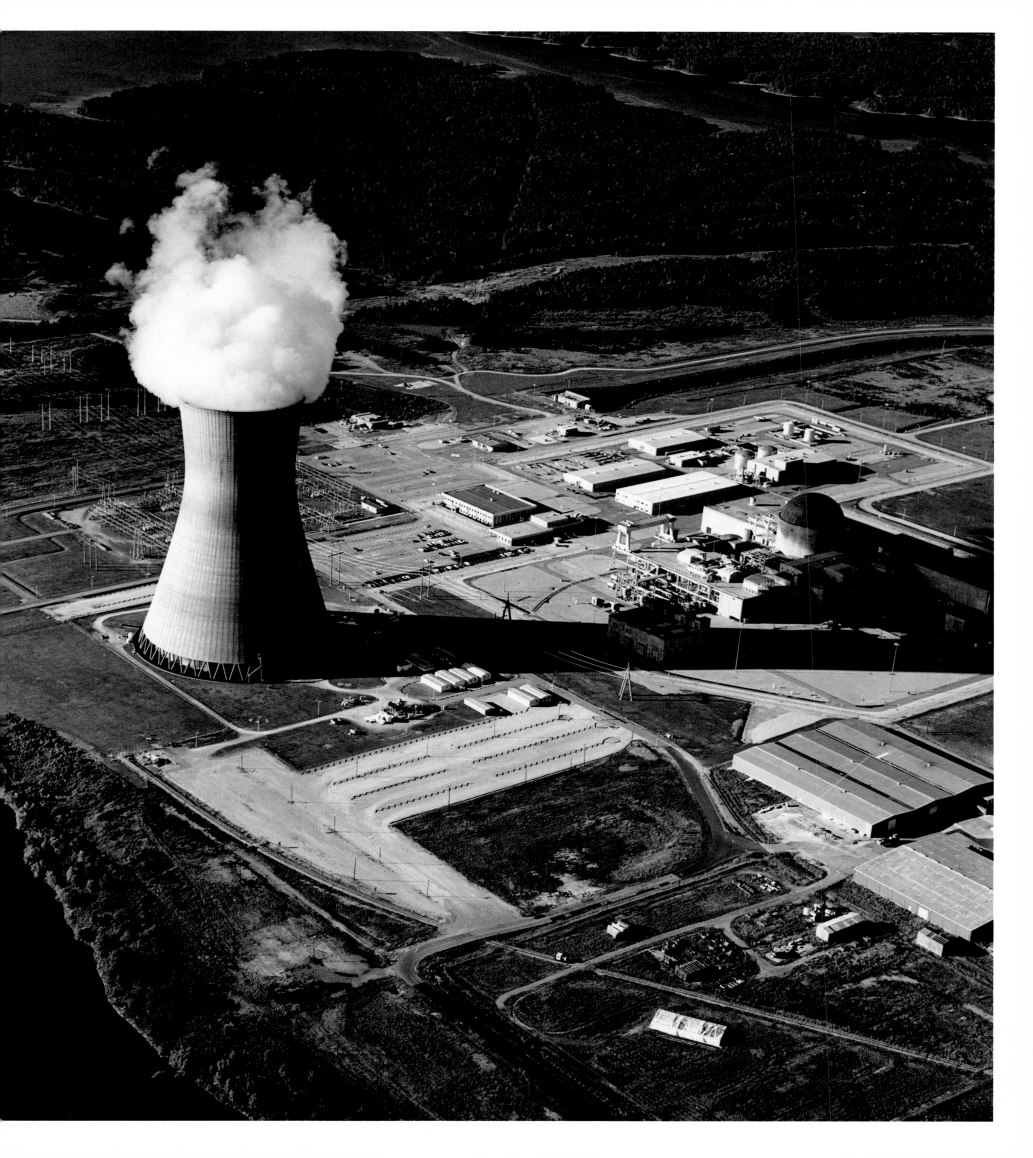

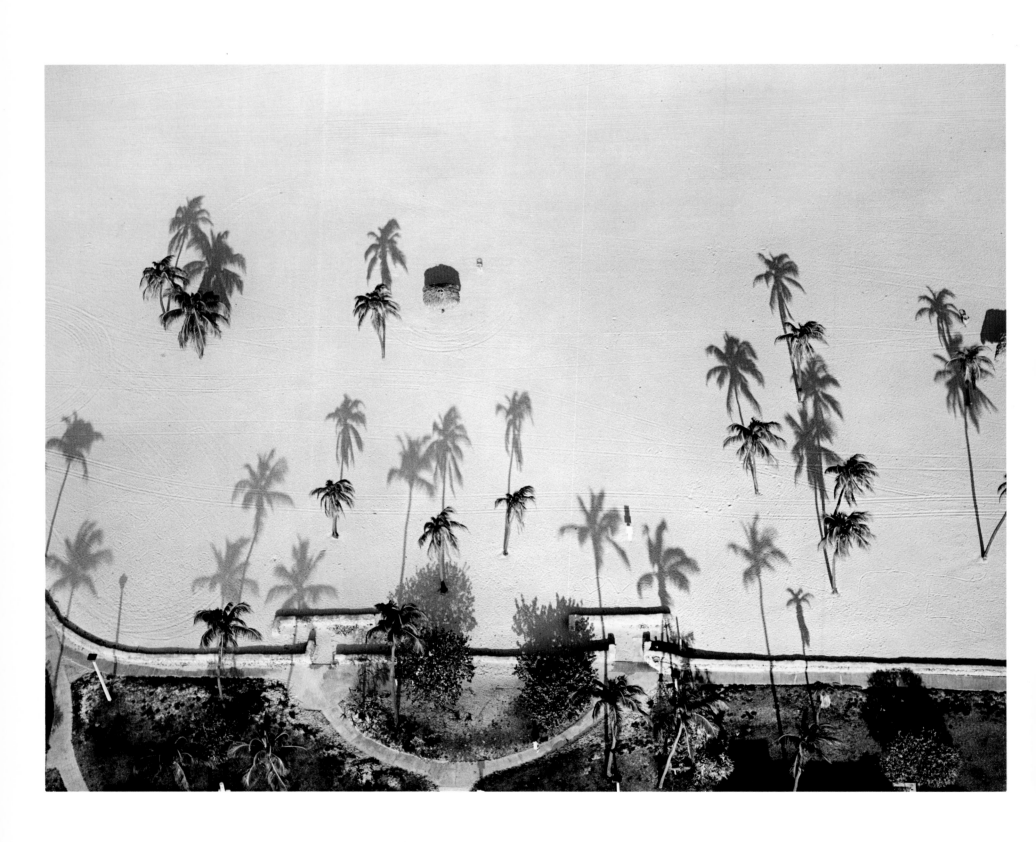

Palm Trees, Miami Beach, Florida, 1987

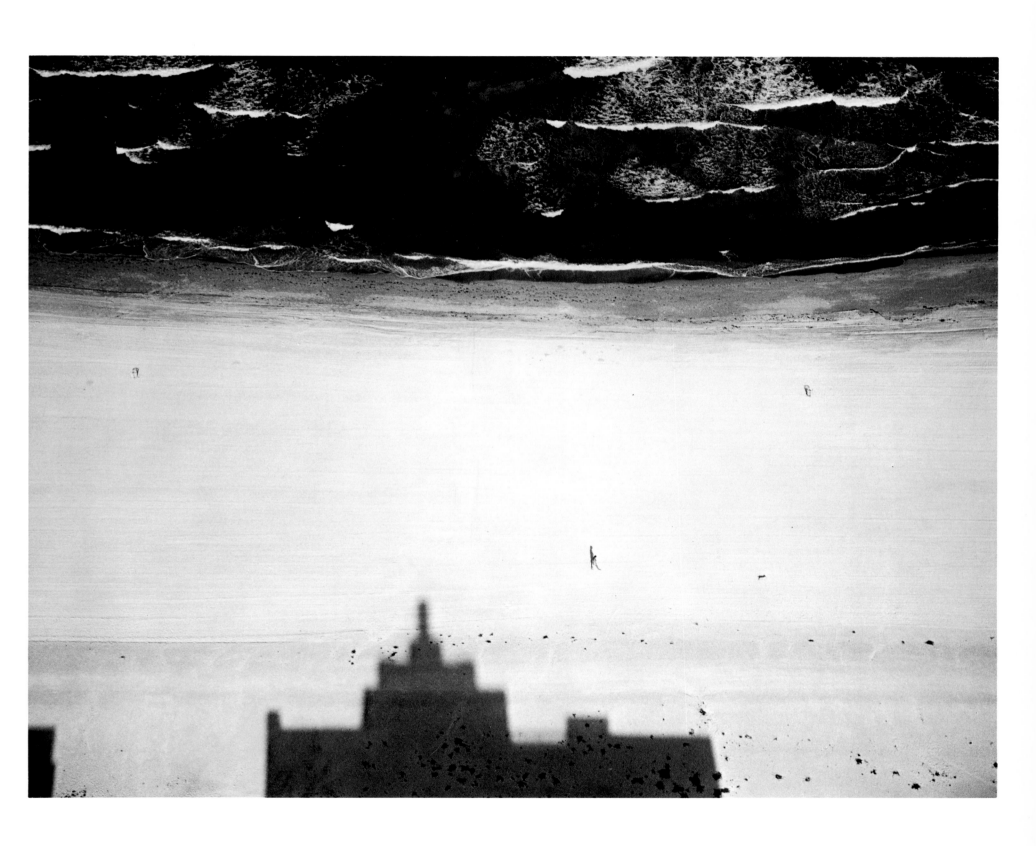

Hotel Shadow, Miami Beach, Florida, 1987

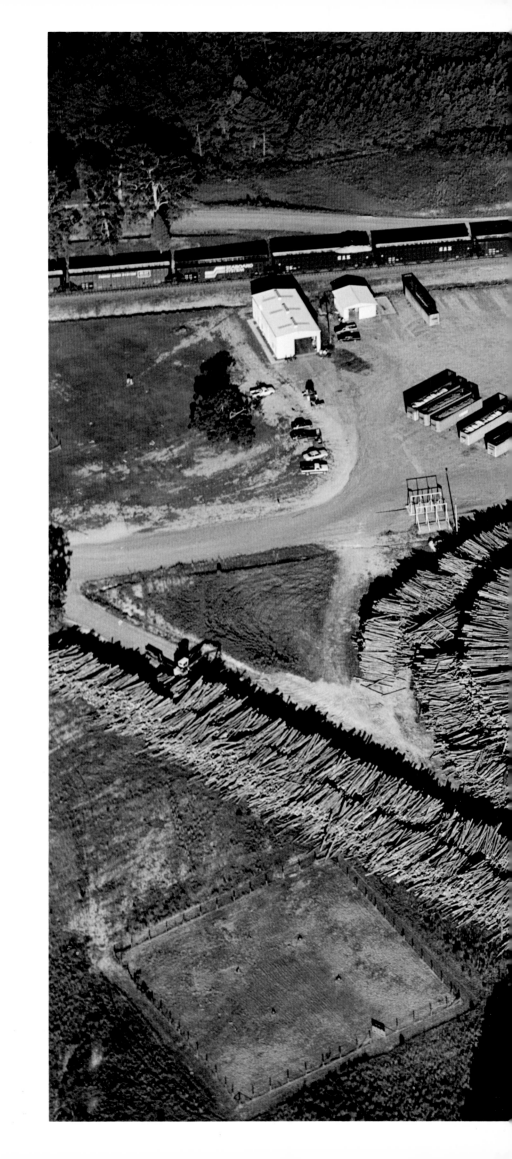

Circular Stacking, Beaufort County, North Carolina, 1993

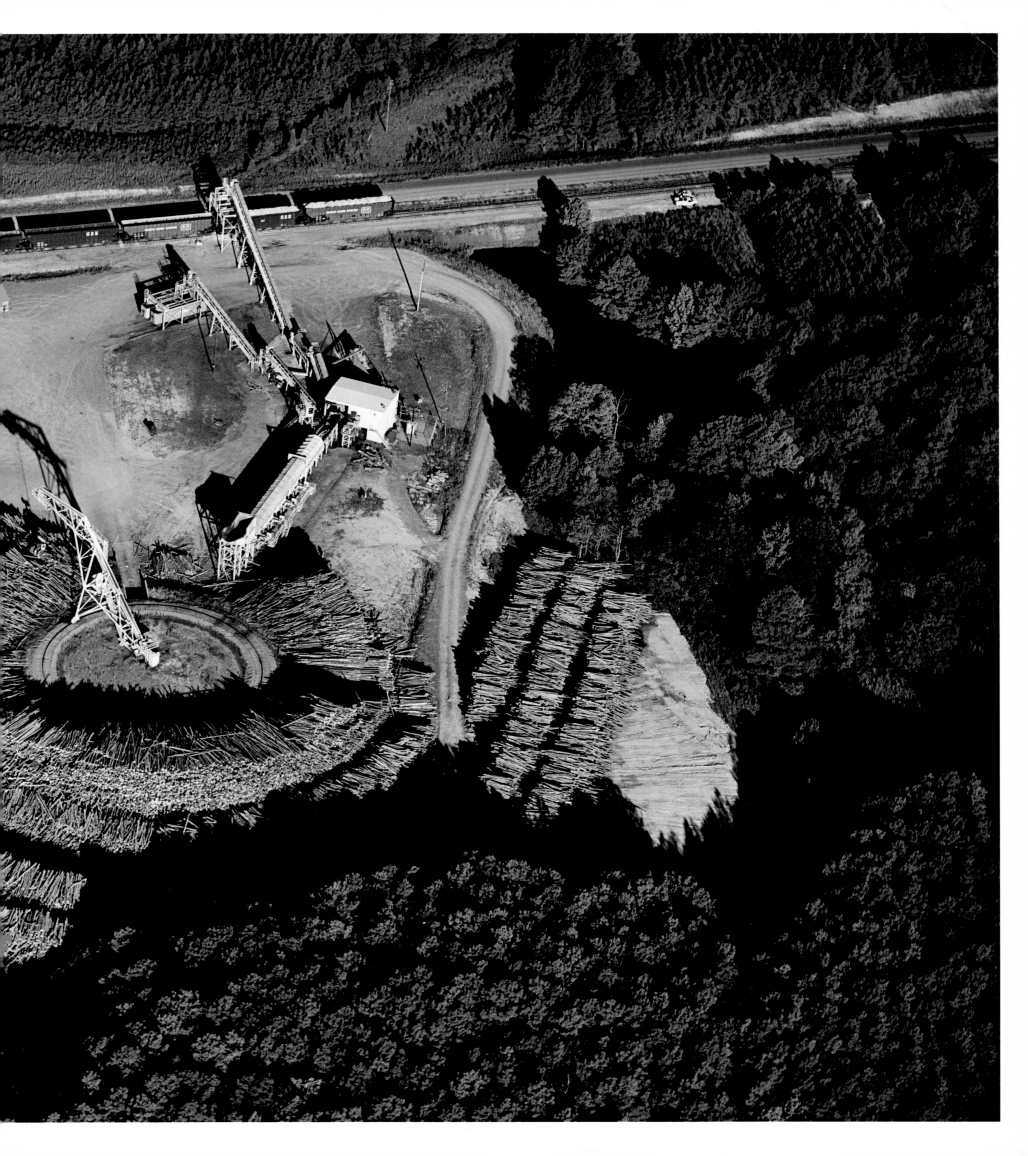

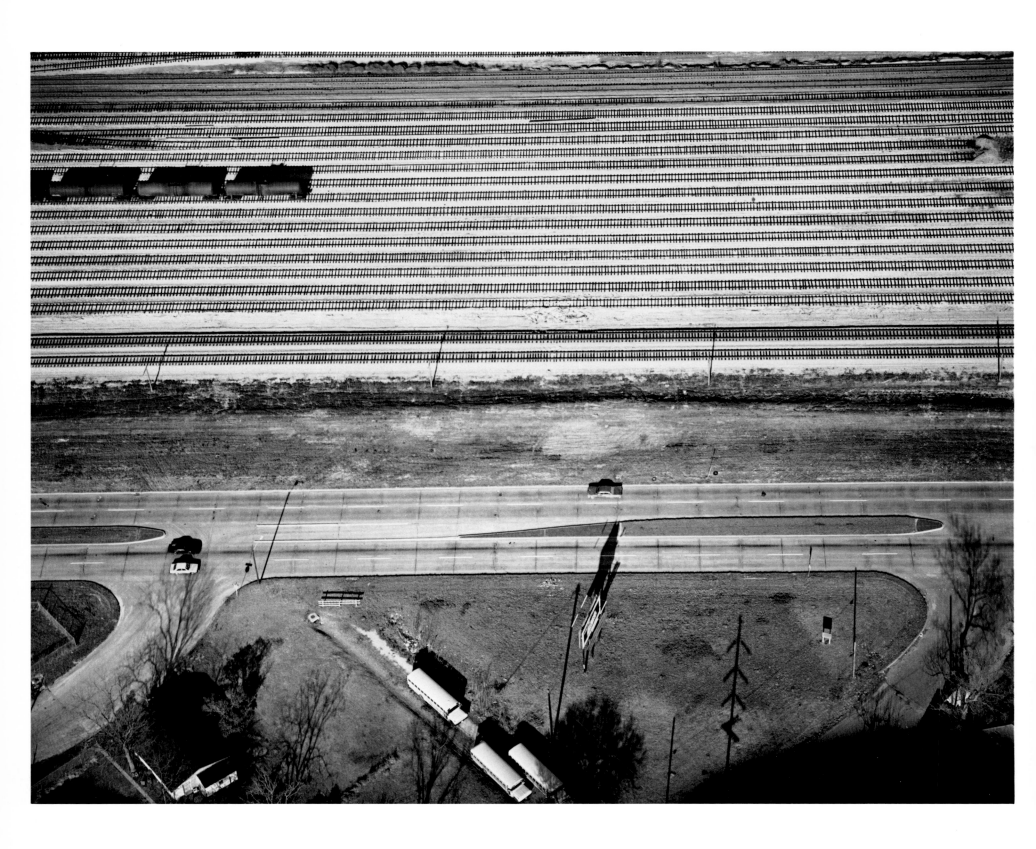

Houston Train Tracks, Houston, Texas, 1988

Houses with Driveways, Florida, 1983

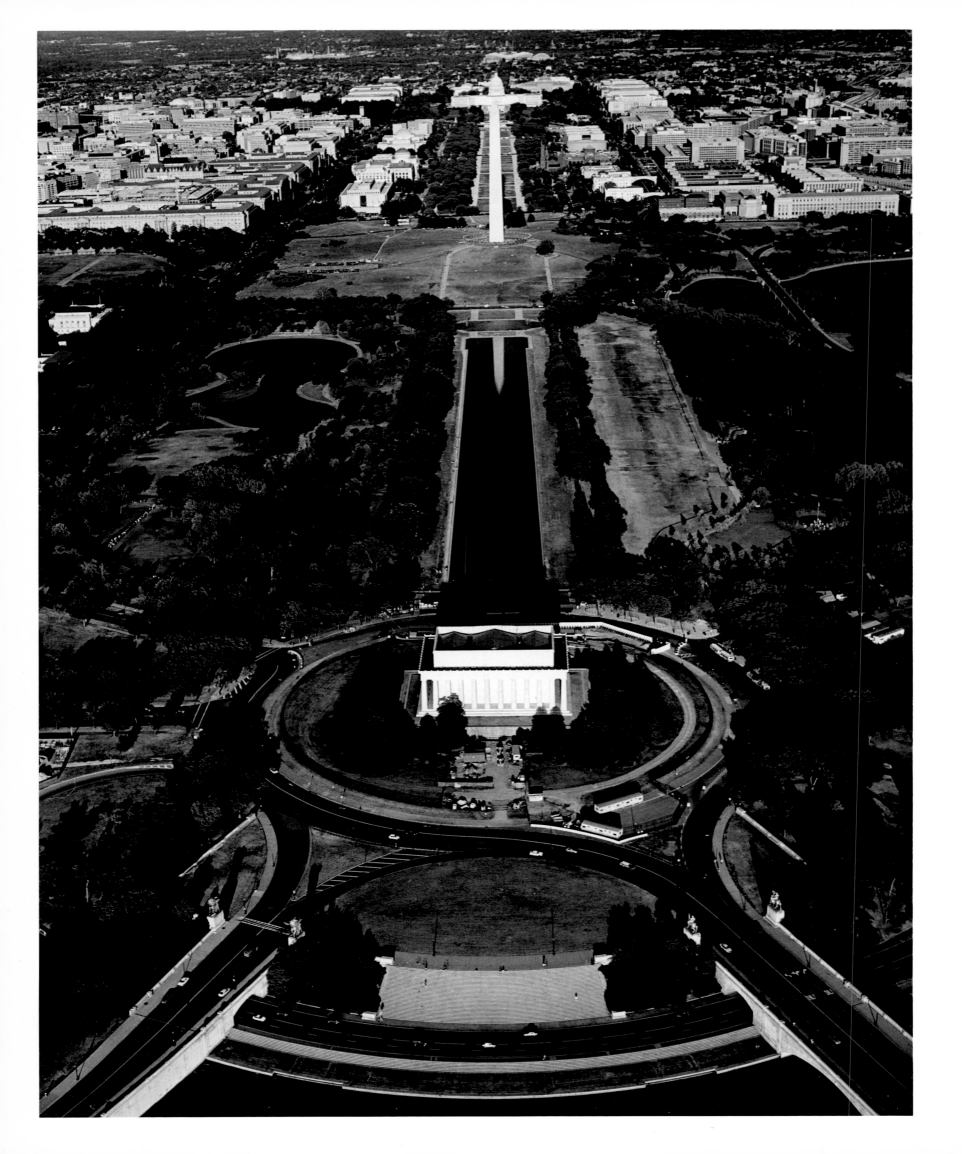

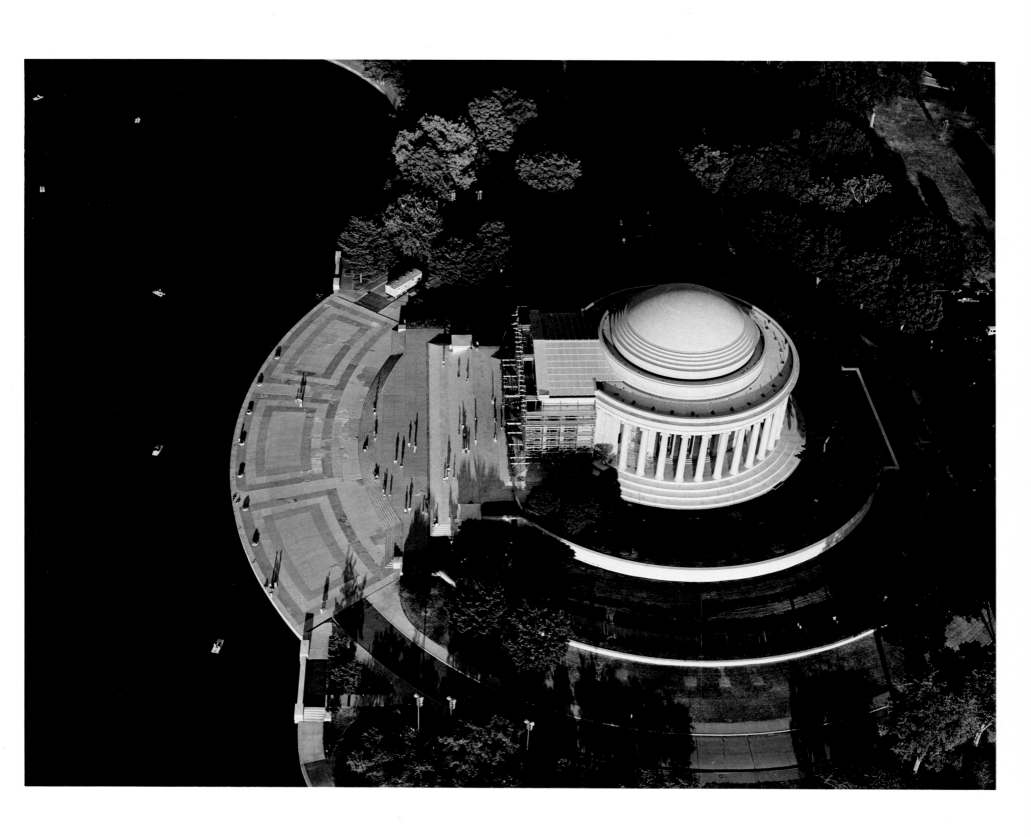

Left: *Lincoln Memorial, Washington Monument, Capitol Building, Washington, D.C., 1995*

Above: *Jefferson Memorial, Washington, D.C., 1995*

Developing Marina, Galveston Bay, Texas, 1994

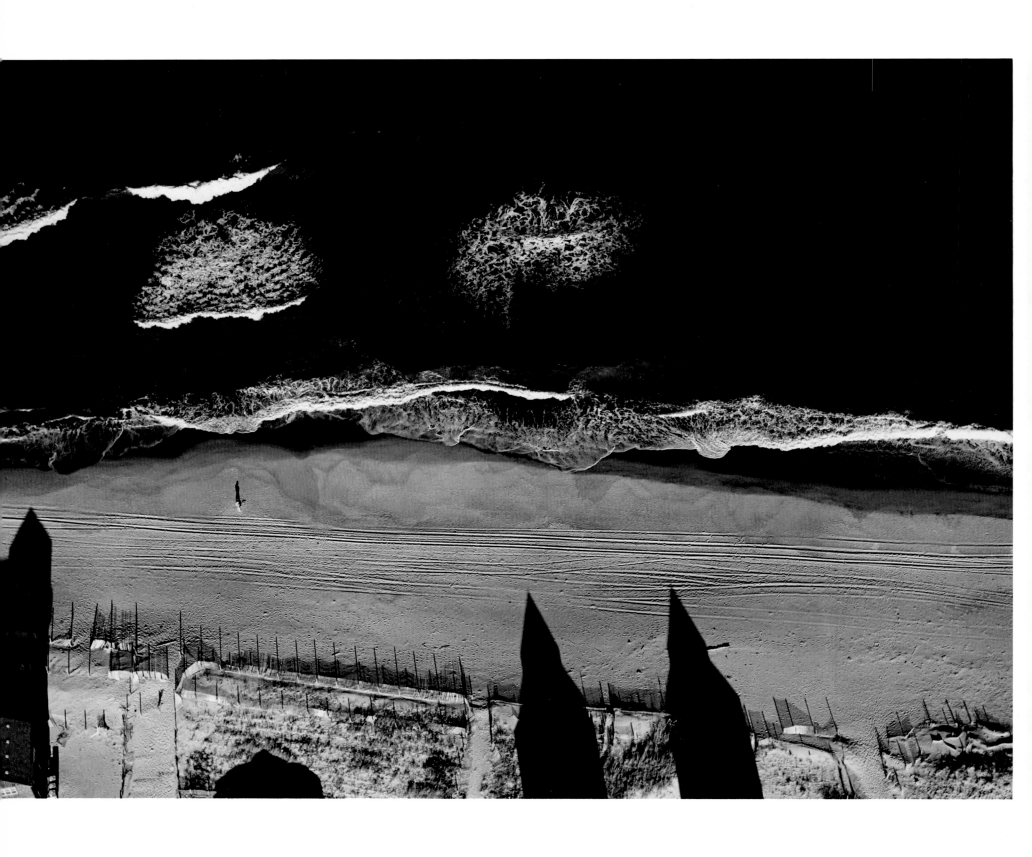

Strolling on the Beach on Ocracoke Island, North Carolina, 1993

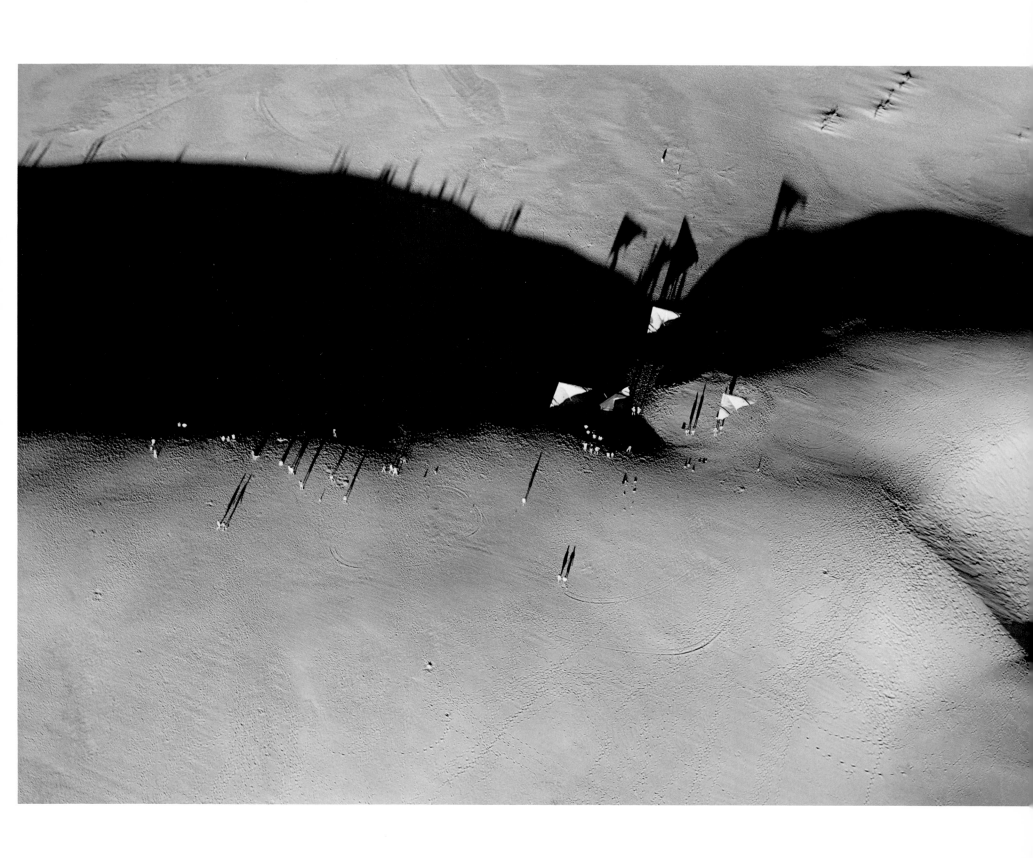

Hang Gliding, Kitty Hawk, North Carolina, 1993

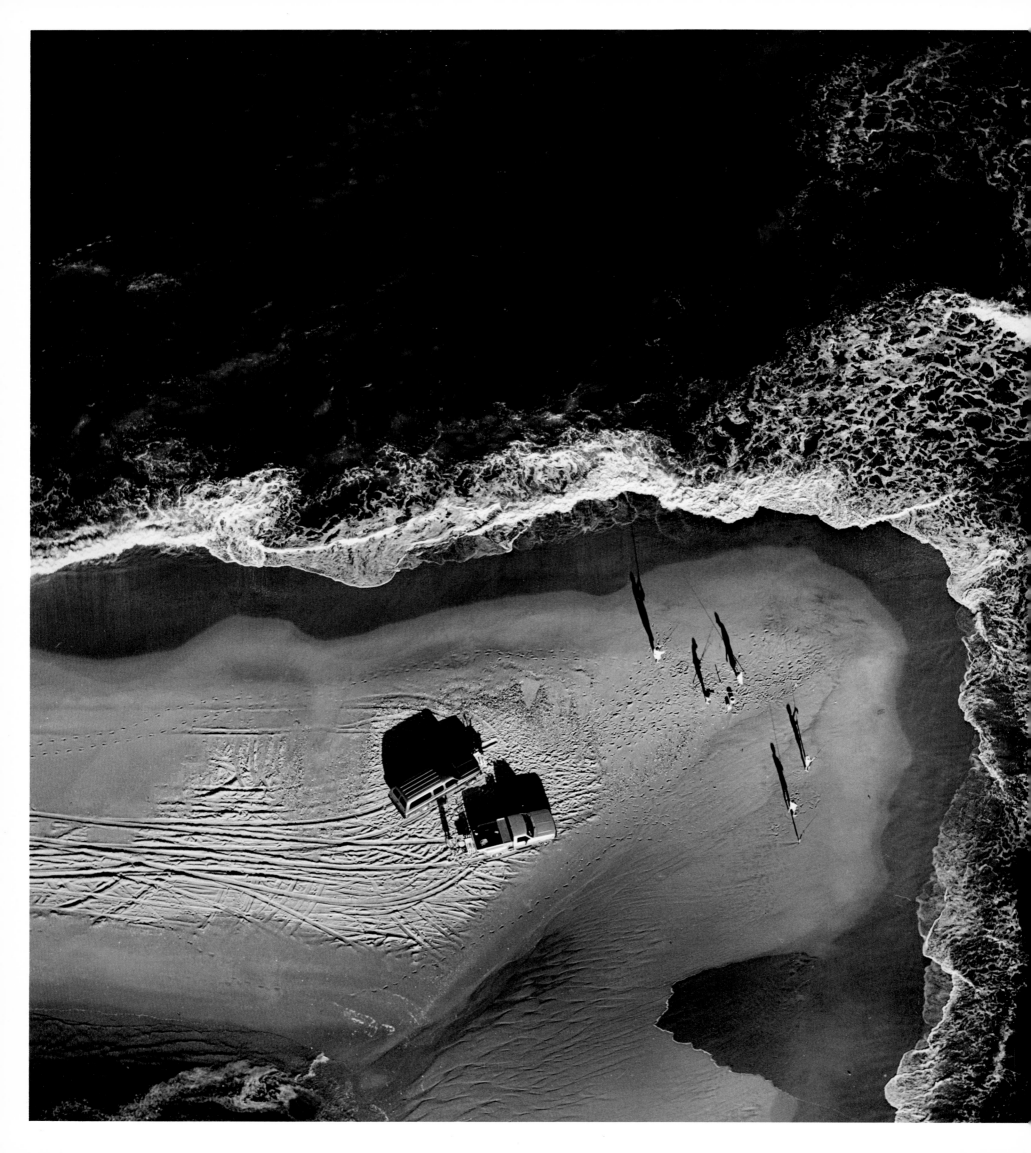

Men Fishing on the Outer Banks, North Carolina, 1993

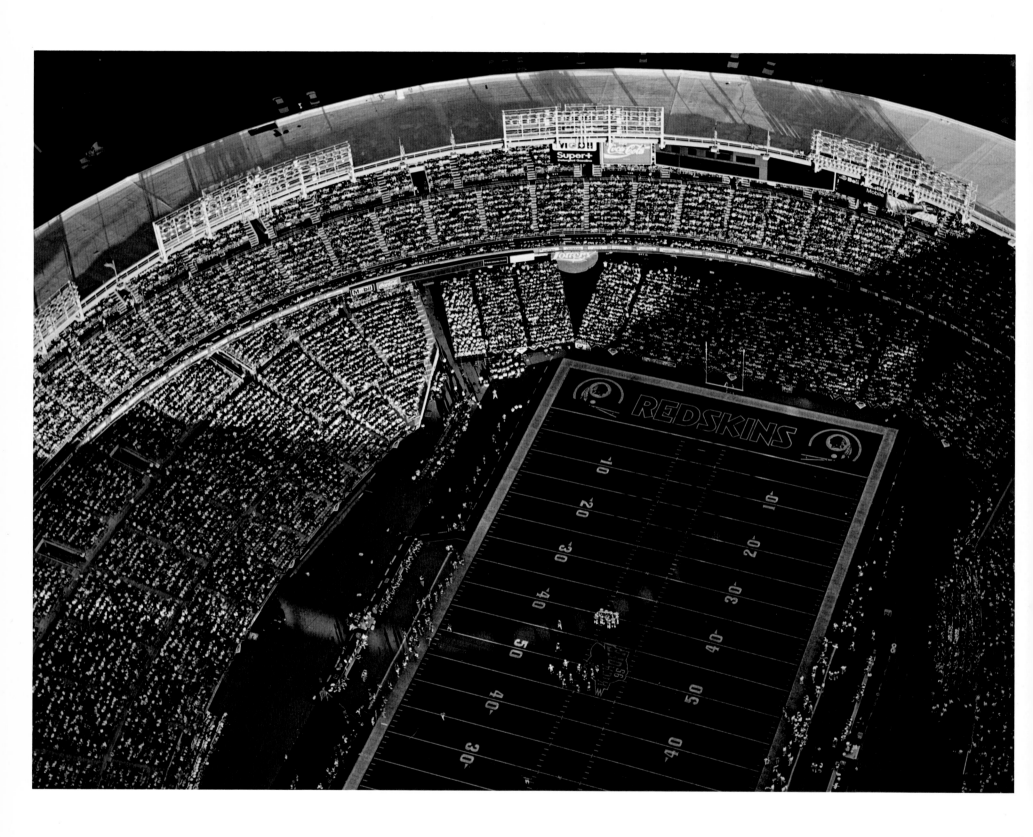

Redskins Game, Washington, D.C., 1995

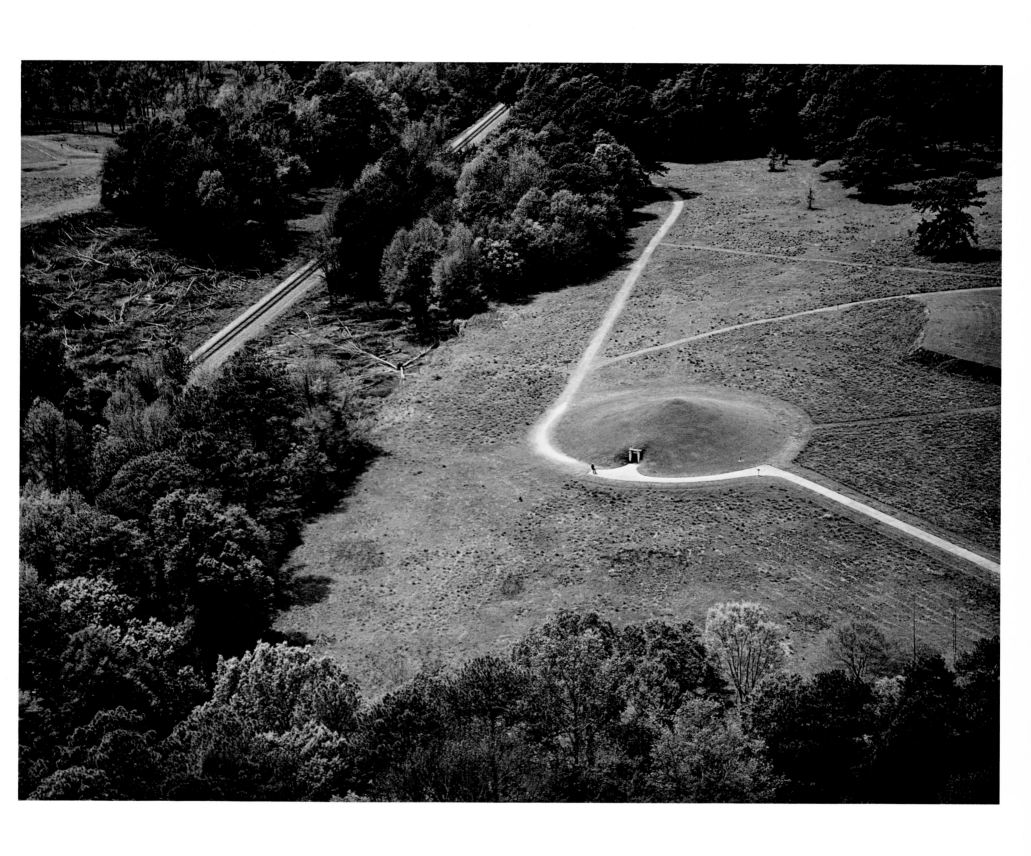

Native American Ceremonial Lodge, Ocmulgee, Georgia, 1992

Industrial Cream Puffs, Houston, Texas, 1988

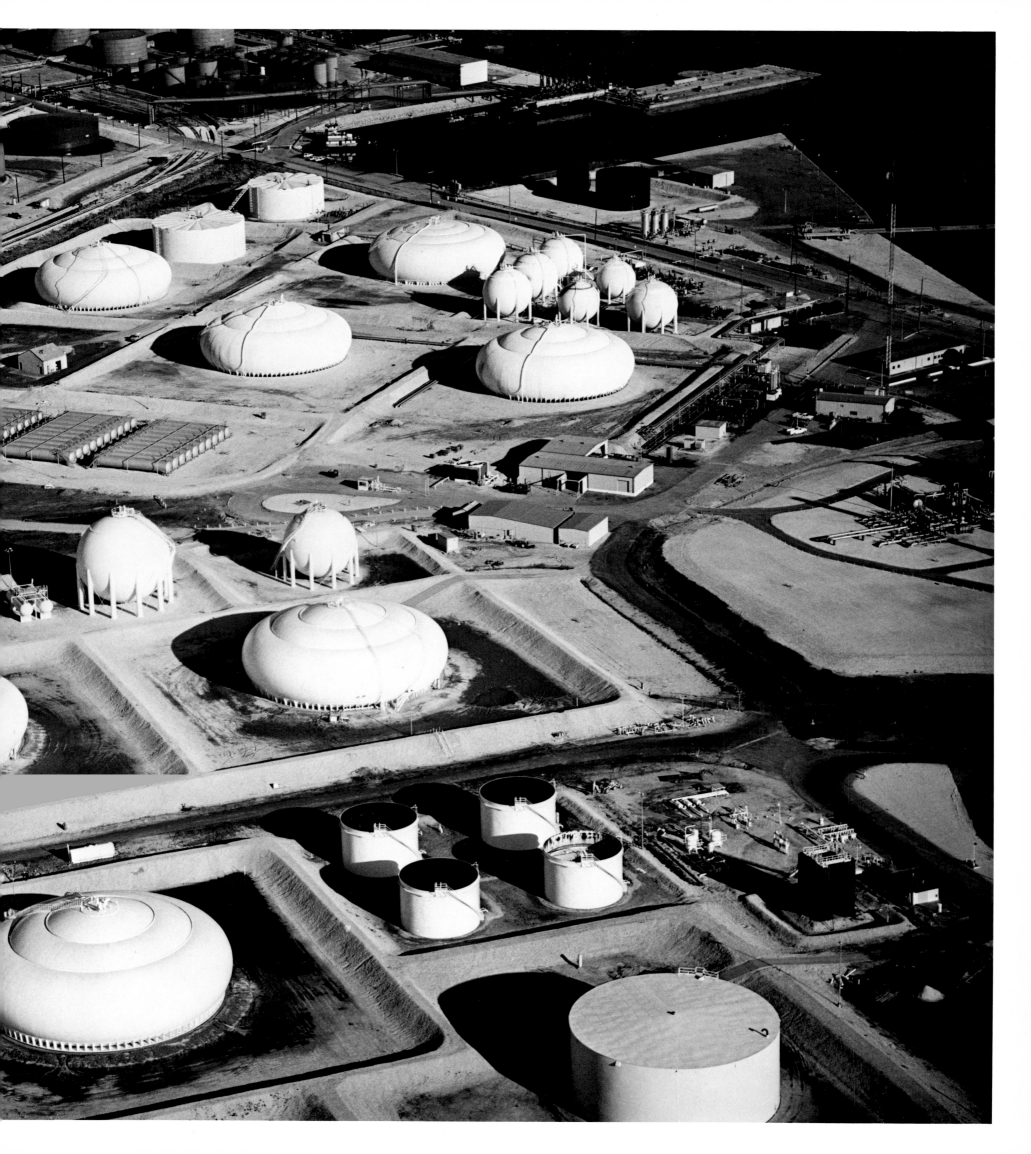

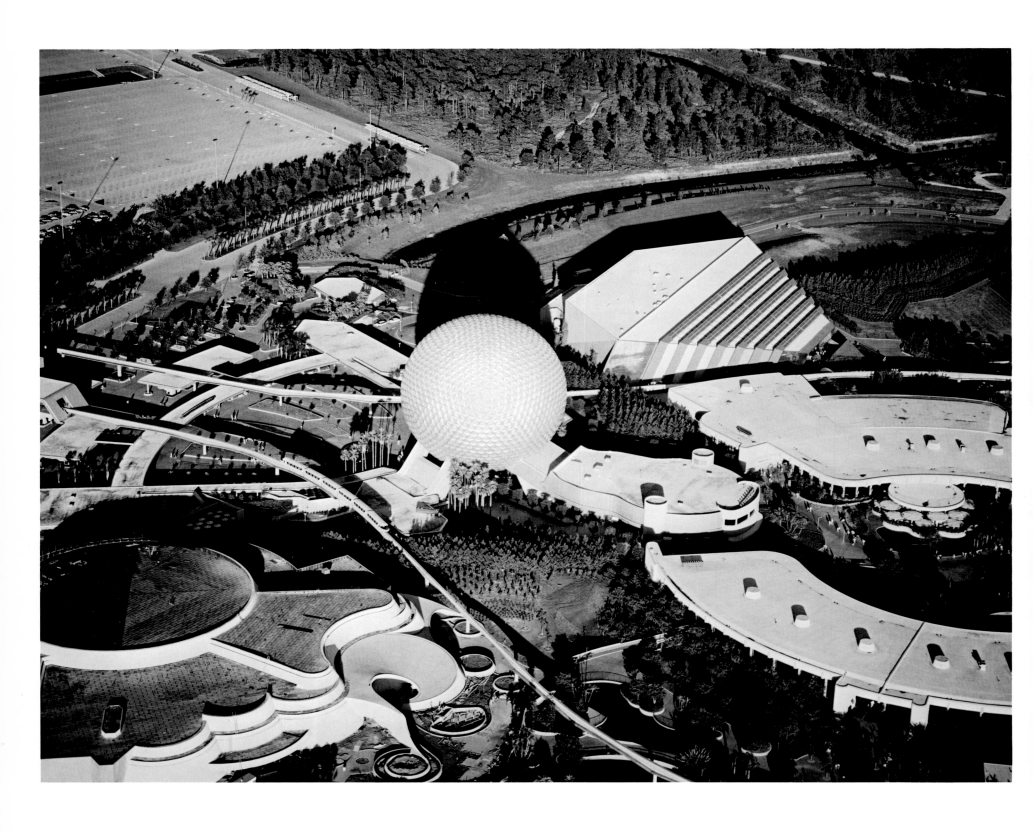

Epcot Center, Orlando, Florida, 1985

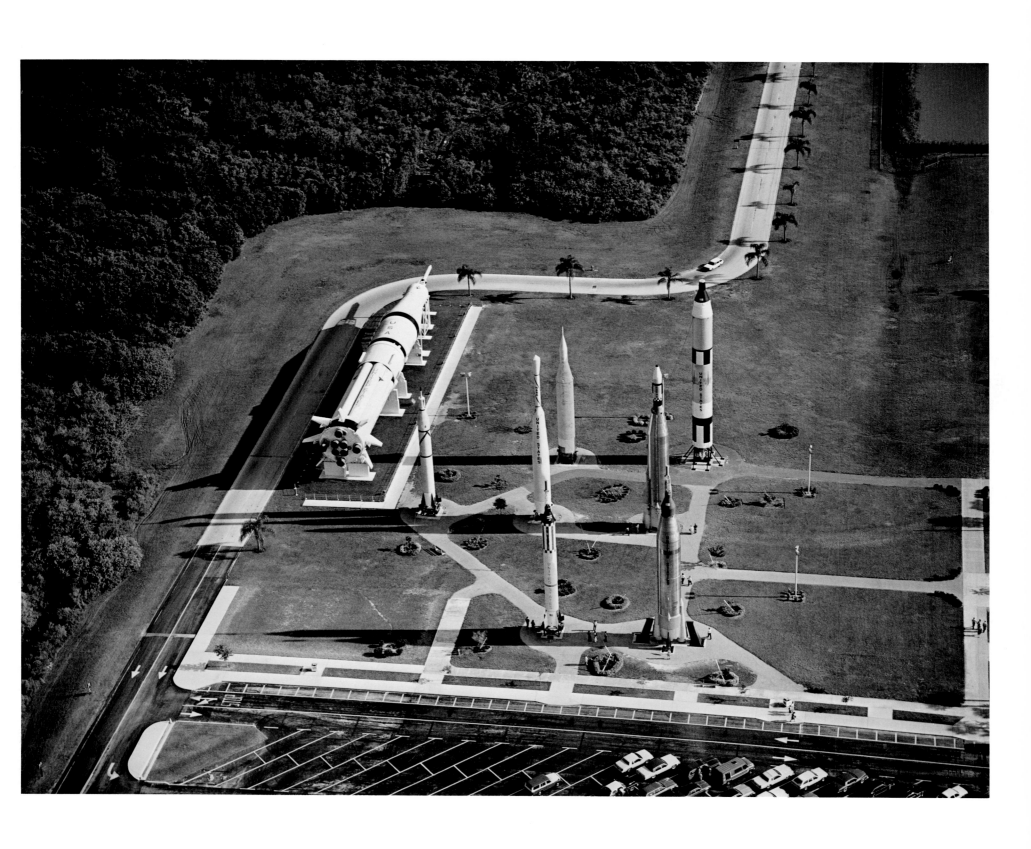

Display of Rockets, NASA, Cape Canaveral, Florida, 1982

The **MIDWEST**

For me, the Midwest is a found and lost land. Doesn't everyone want to go east or west? I find the Midwest's identity elusive—its personality confused, its isolation contagious. Geographically, it is more *midway* than *midwest.* Like the West, it resists change. Like the East, it both triumphs over progress, and suffers the ill effects of progress more acutely. Where it borders the West, buffalo still graze. The remains of Native American icons form backdrops to modern development. Like the great hands clasped in prayer in Tulsa, the region seems to be on the verge of calling on divine intervention to heal its wounds and bless its future.

Praying Hands, Oral Roberts University, Tulsa, Oklahoma, 1991

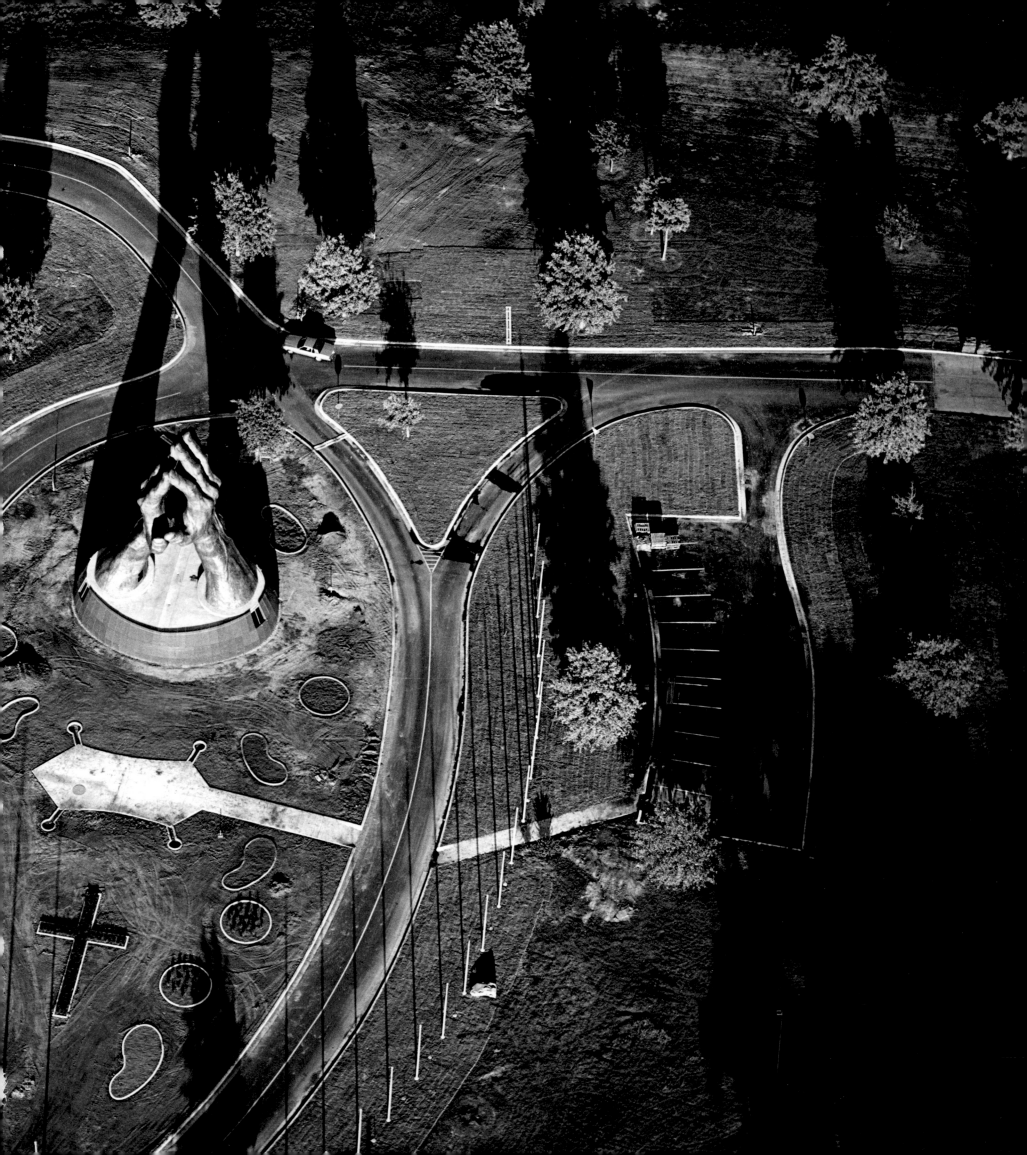

Oklahoma Mask, Kiowa County, Oklahoma, 1987

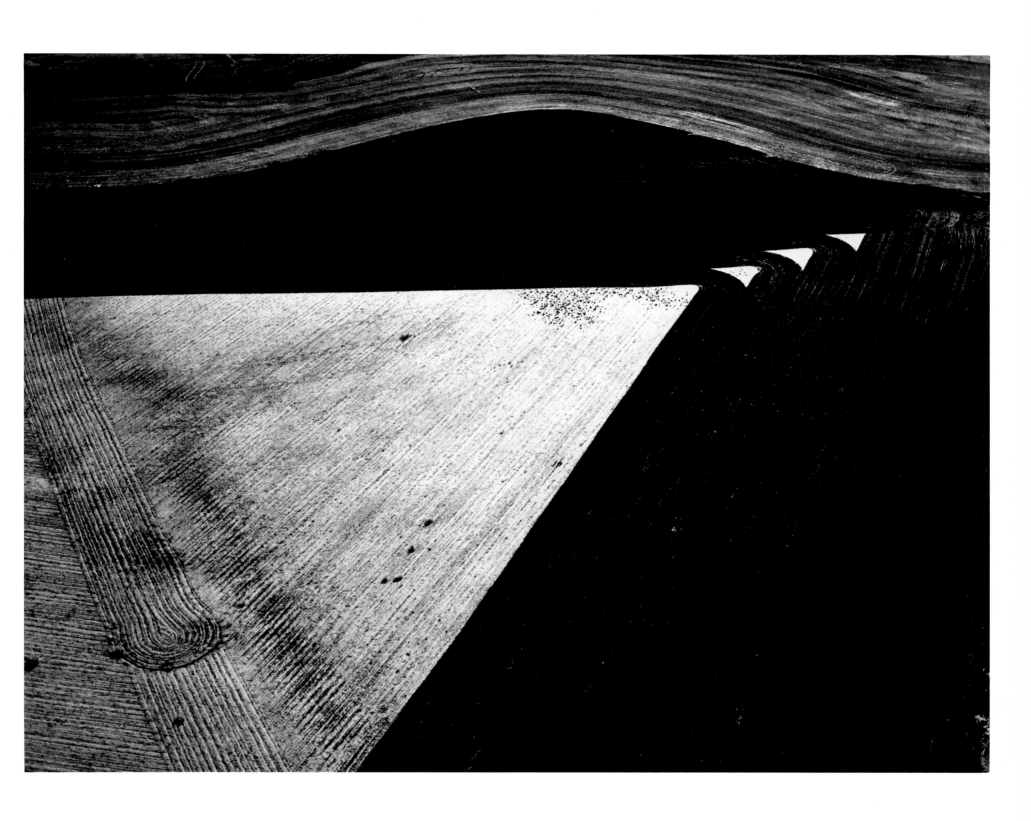

Geometrics, Lone Wolf, Oklahoma, 1987

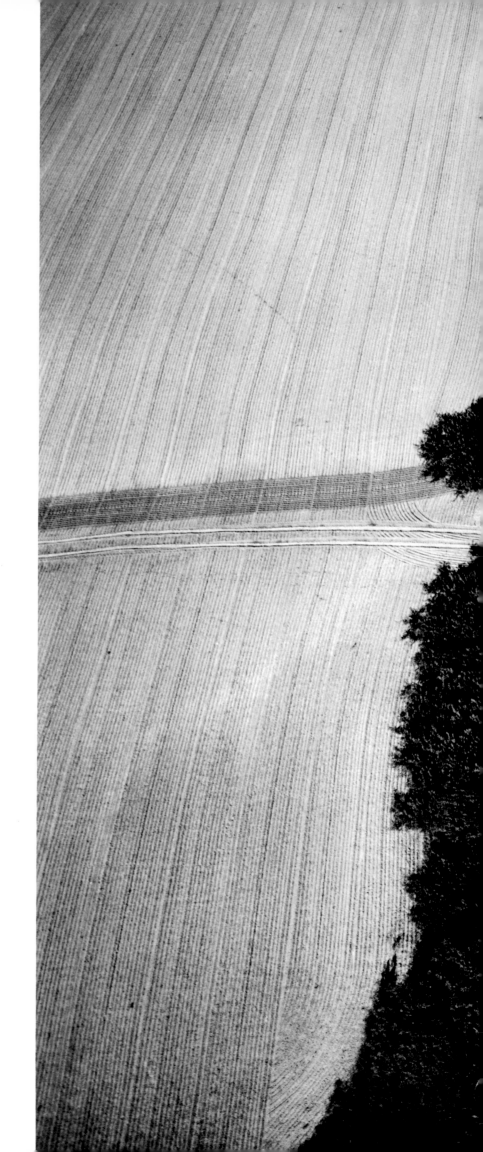

Isolation Farmhouse, Greer County, Oklahoma, 1987

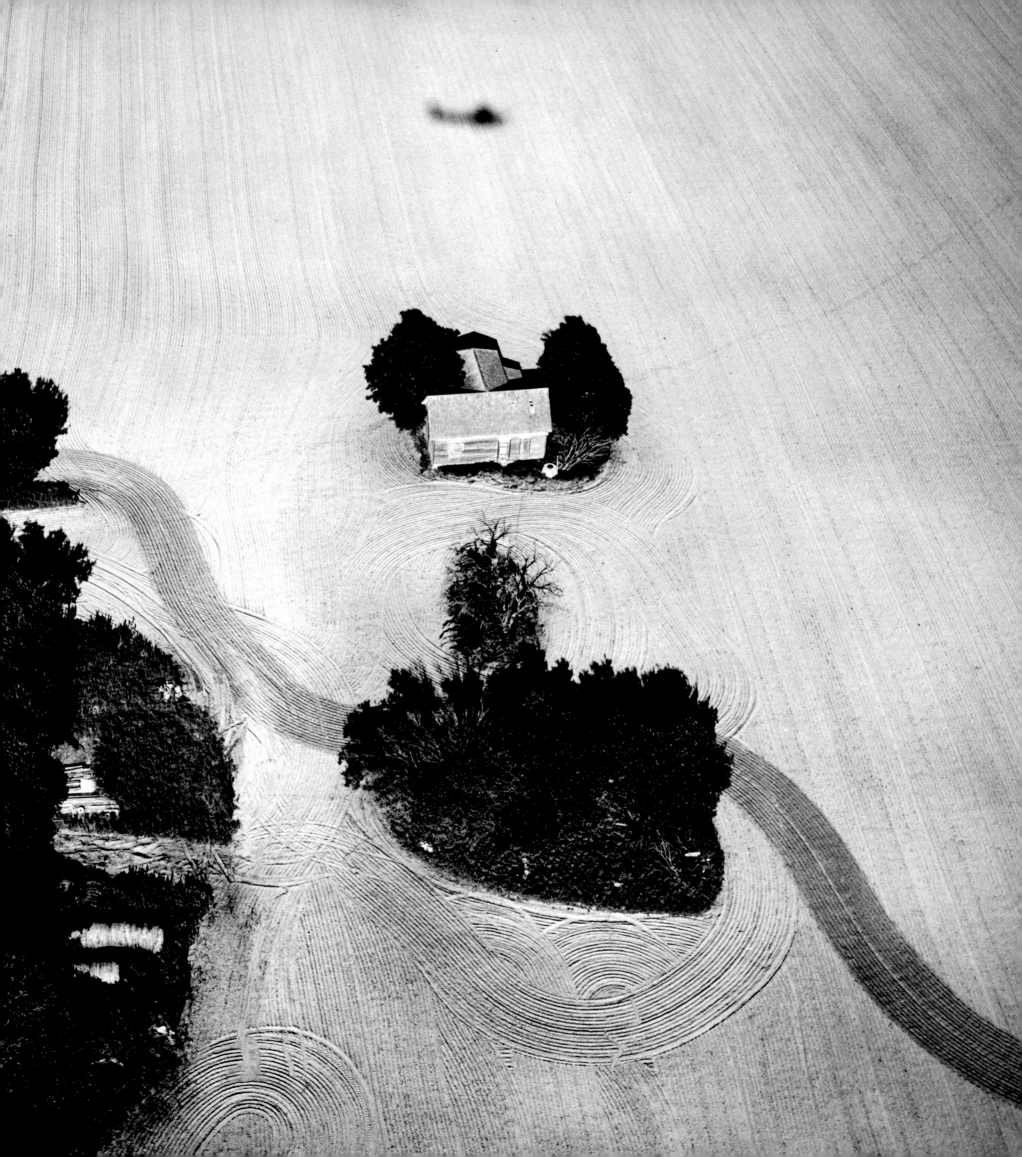

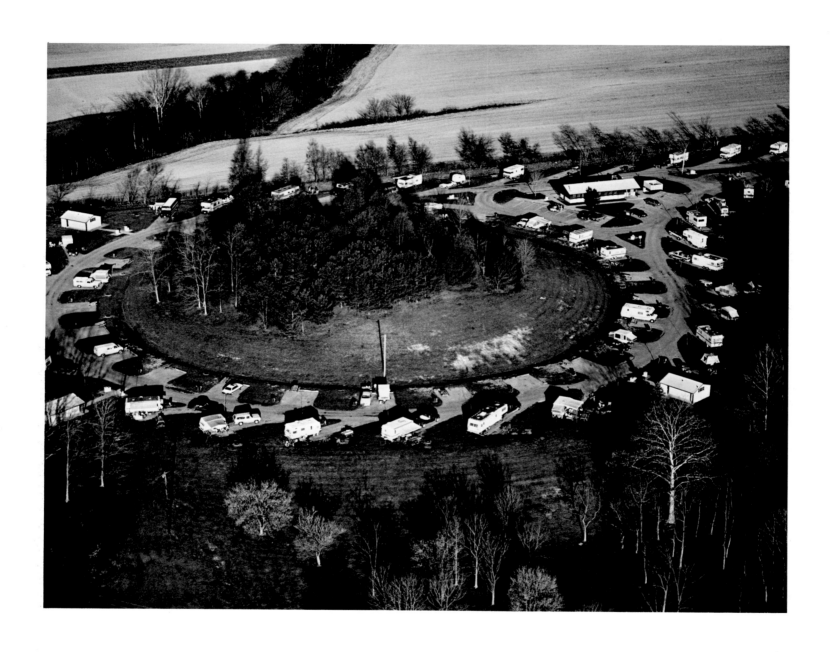

Above: *Trailer Park Surrounds Hopewell Burial Mound, Ohio, 1987*

Right: *Golf Course Covers Geometry of Ancient Ceremonial Site, Newark, Ohio, 1983*

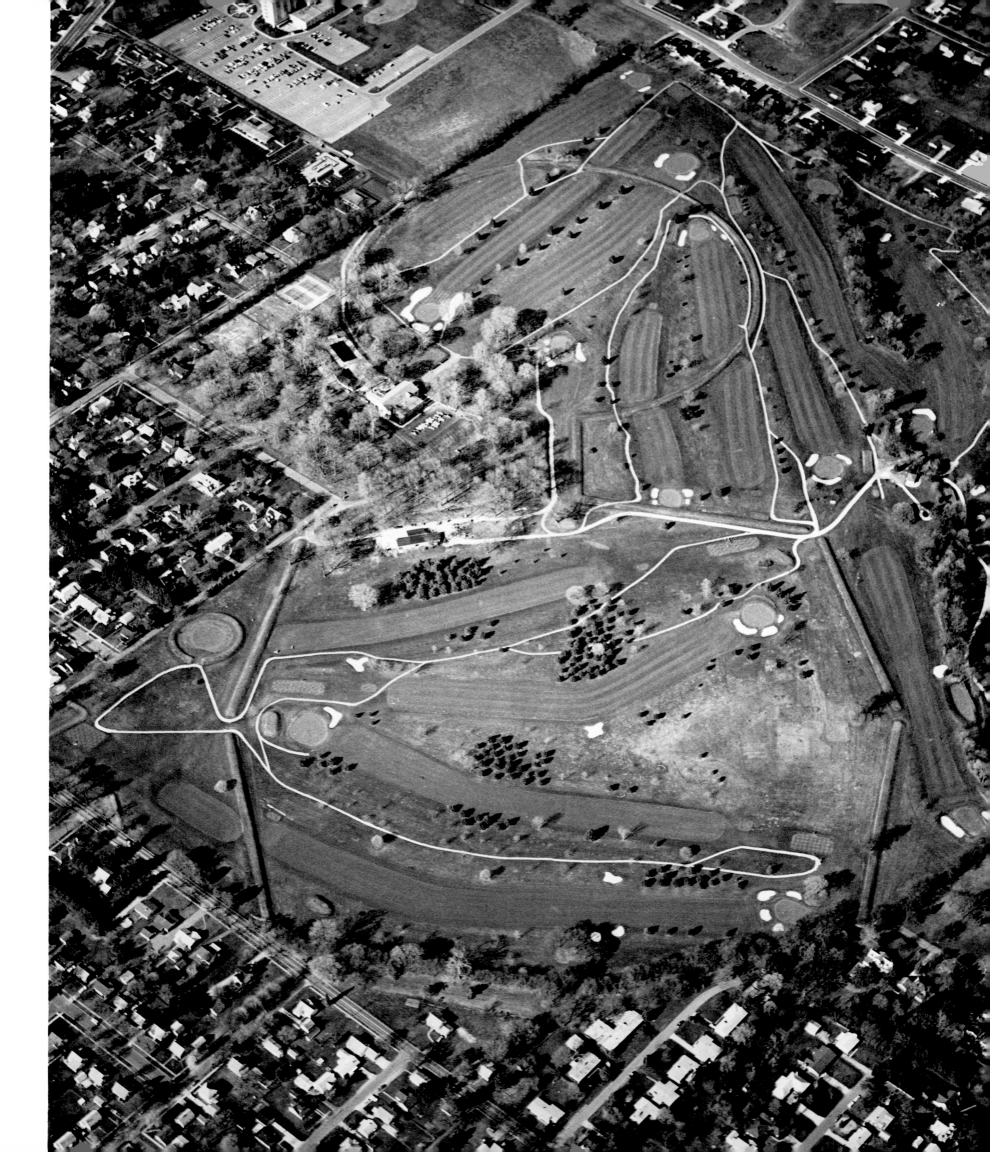

Ancient Bear Effigy Mound Overlooking Town of Marquette, Iowa, 1984

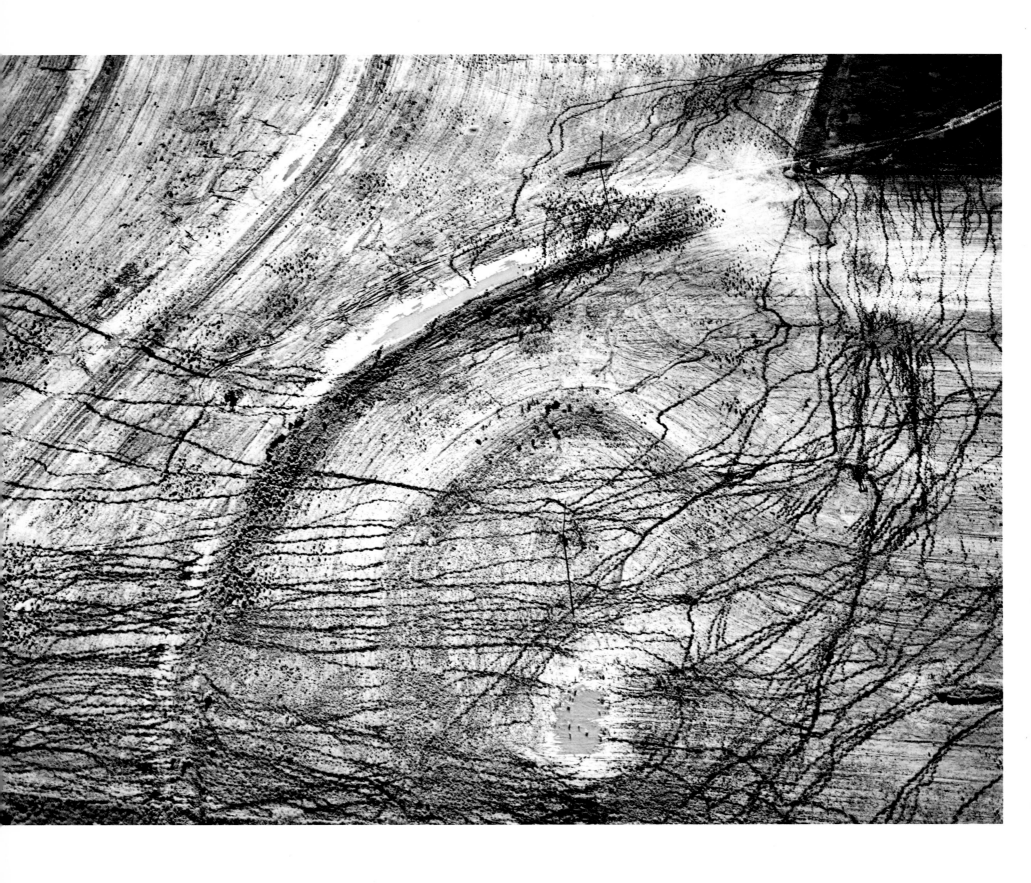

Cattle Tracks, Quartz Mountain, Oklahoma, 1987

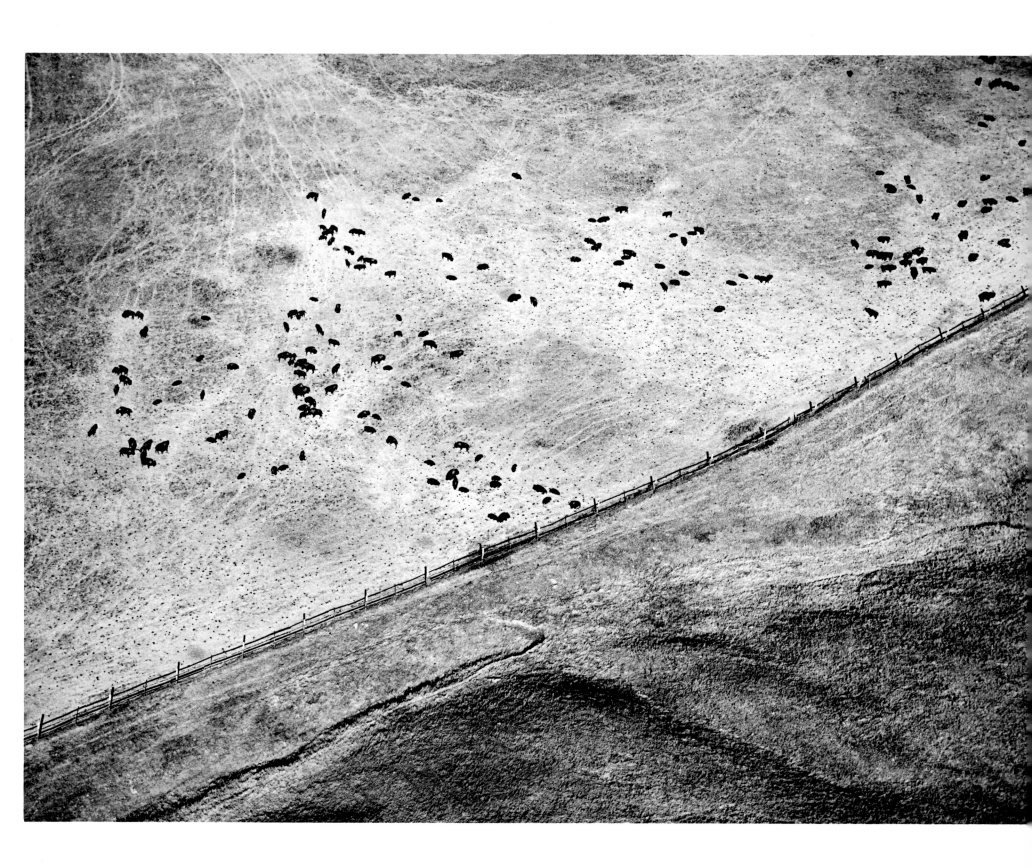

Buffalo in the Badlands, South Dakota, 1984

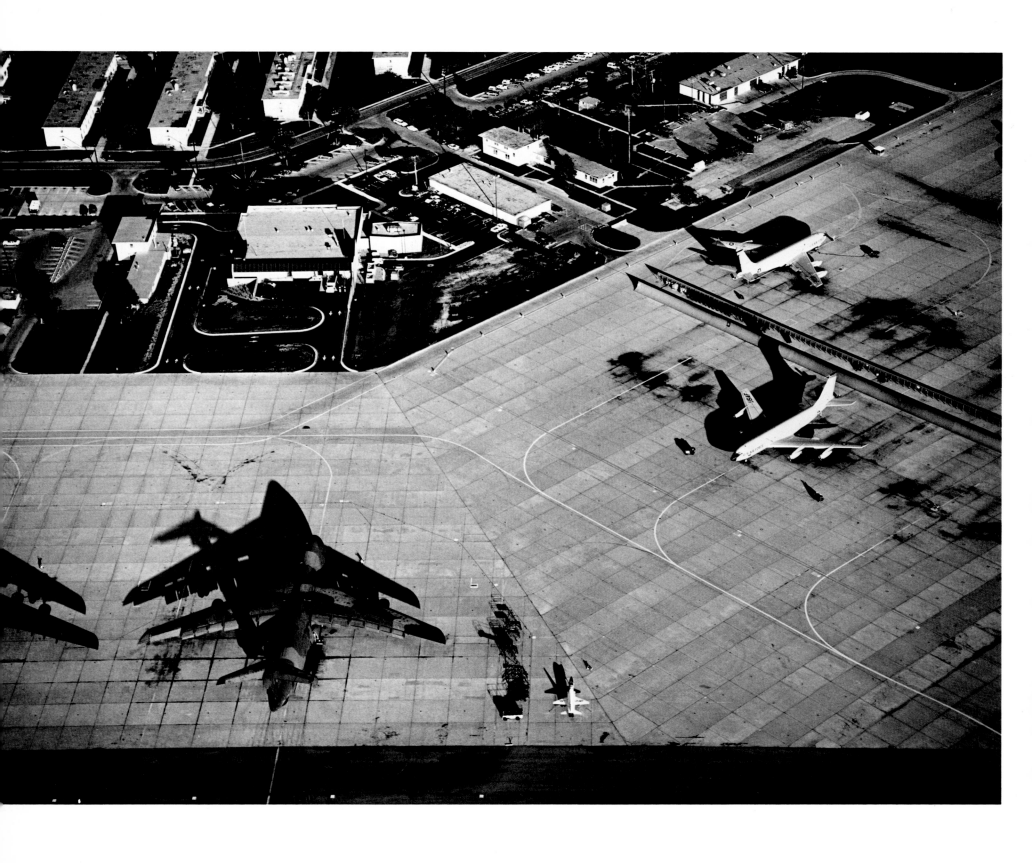

Altus Air Force Base, Oklahoma, 1987

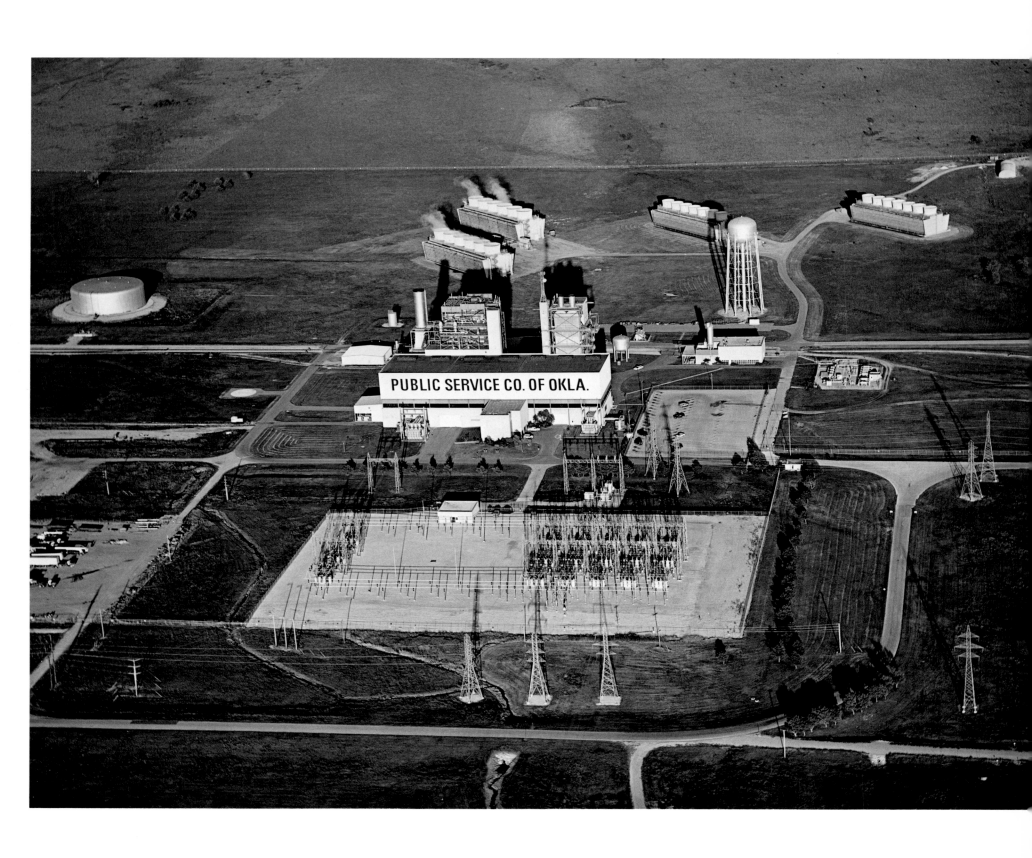

Public Service Co. of Oklahoma, Tulsa, Oklahoma, 1991

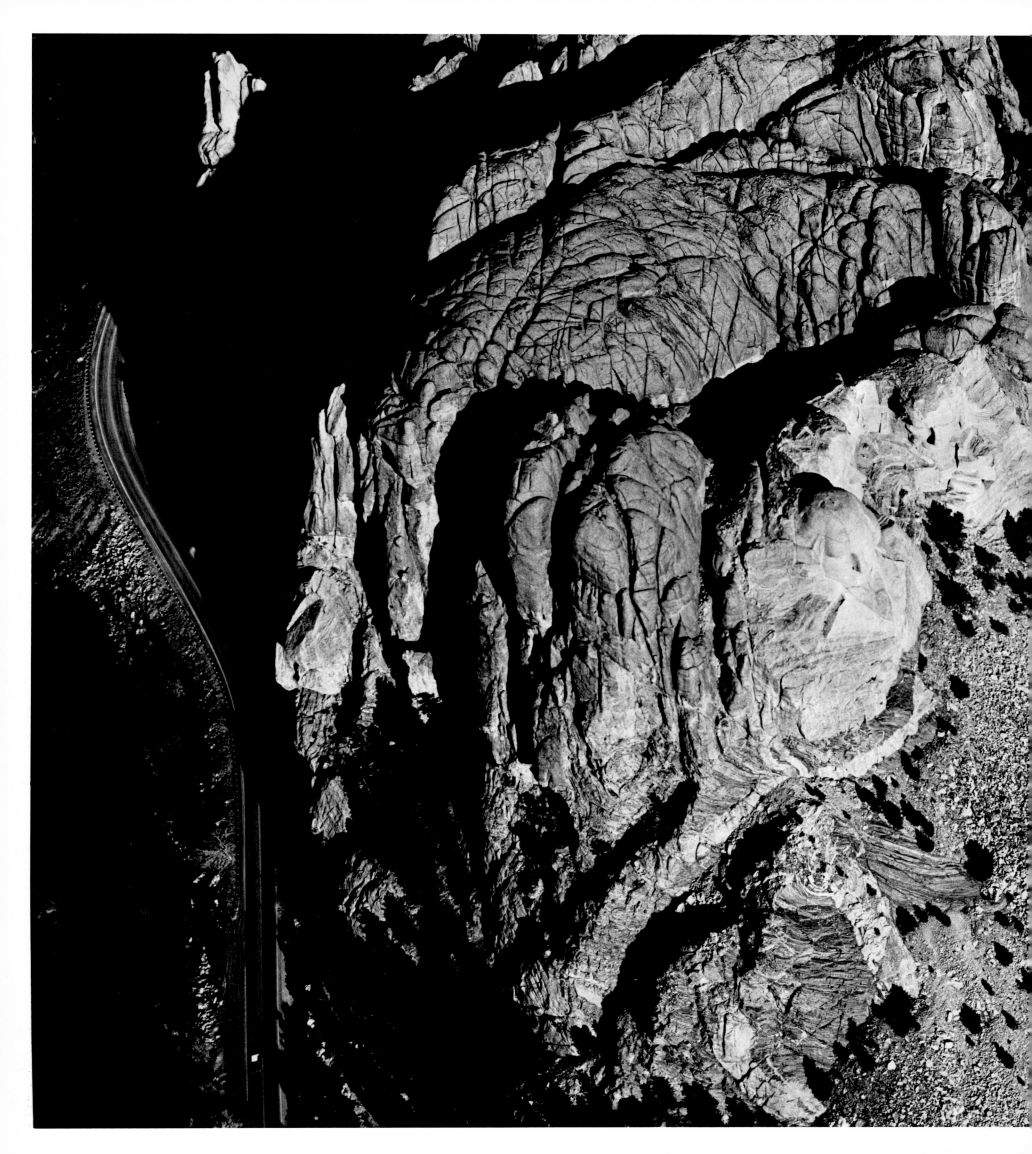

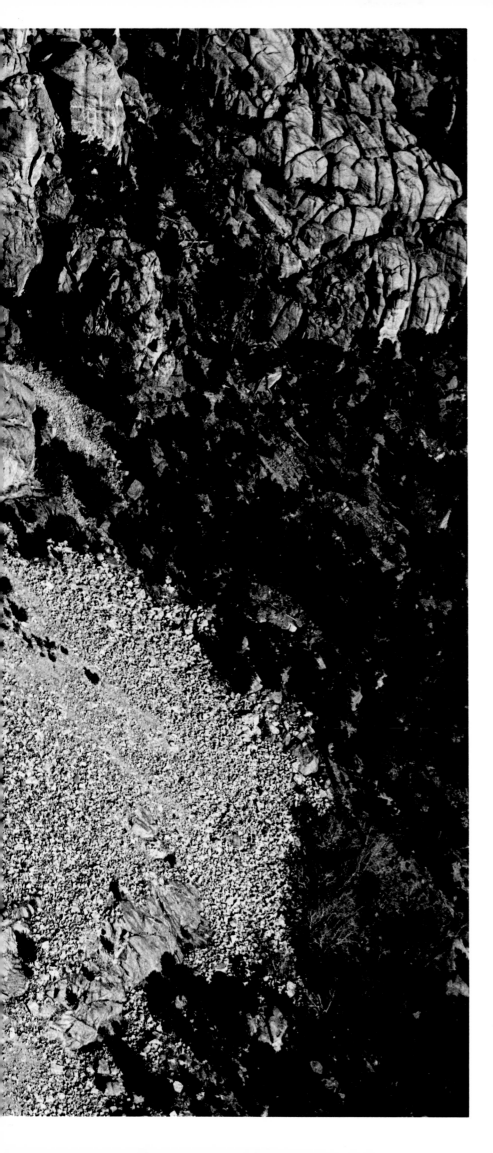

Mount Rushmore, The Badlands, South Dakota, 1984

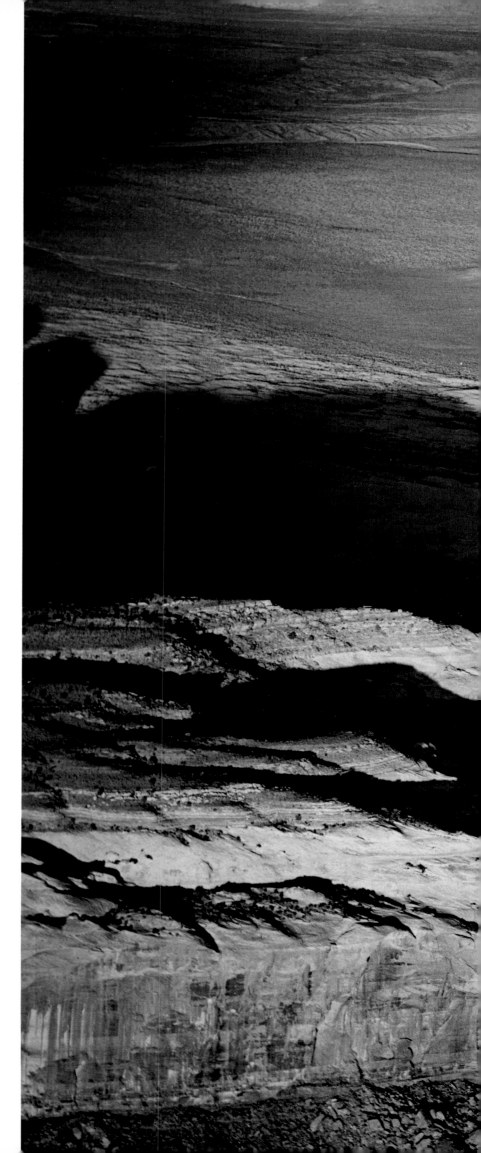

The **WEST**

Often when I fly over the American West the boundless beauty of the landscape overwhelms me completely. Below me I sense the rugged and much-weathered features of a wise and resolute old god. Eternity seems to stretch before my eyes. And yet I am often reminded—when the remains of clear cutting and mining scar the earth—that it is here in the West that the front line of the epic struggle between man and Nature is being fought. Unchecked development not only threatens the sanctity of Nature, it threatens to evoke a disastrous response.

Journey, Monument Valley, Arizona/Utah, 1983

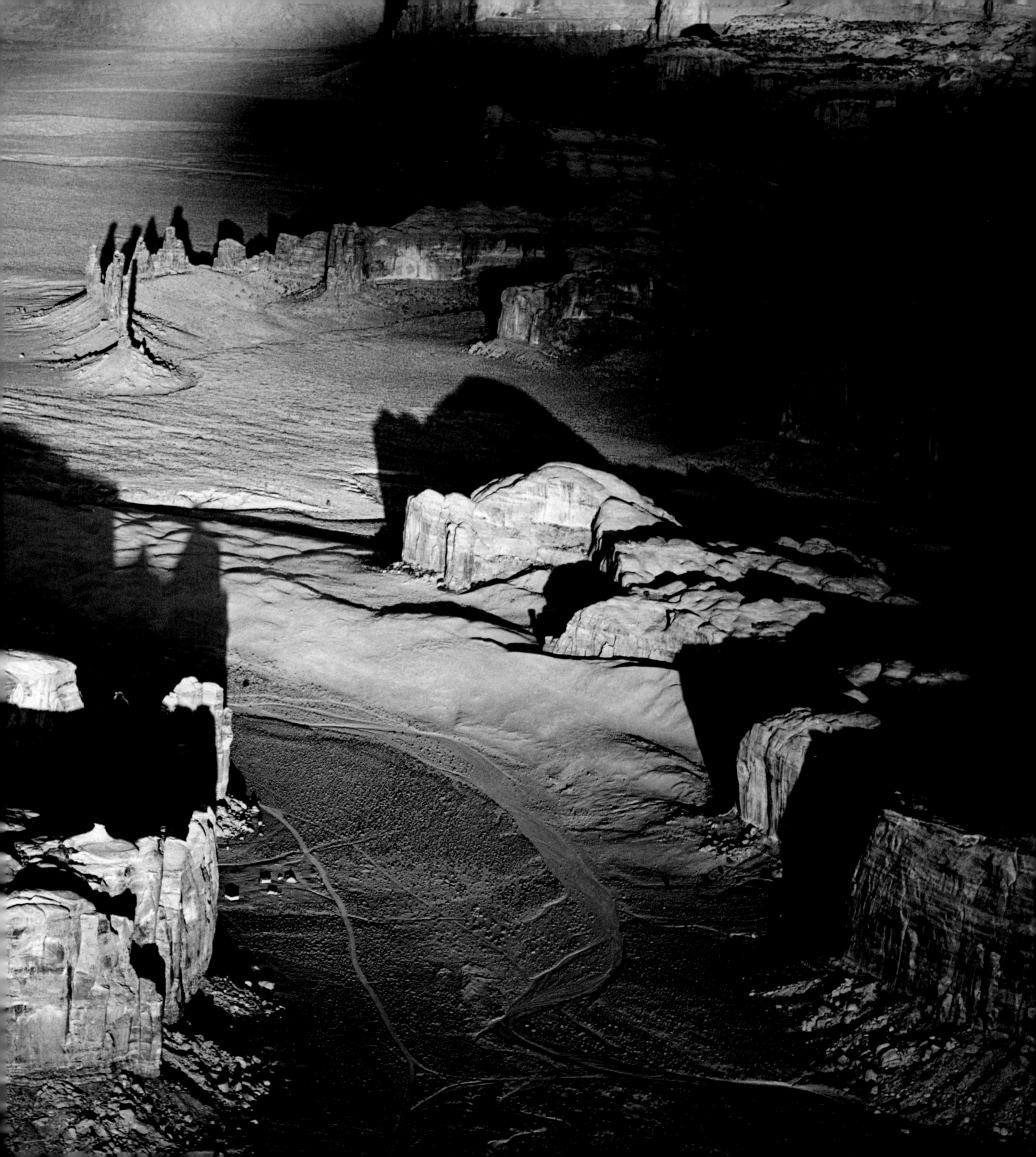

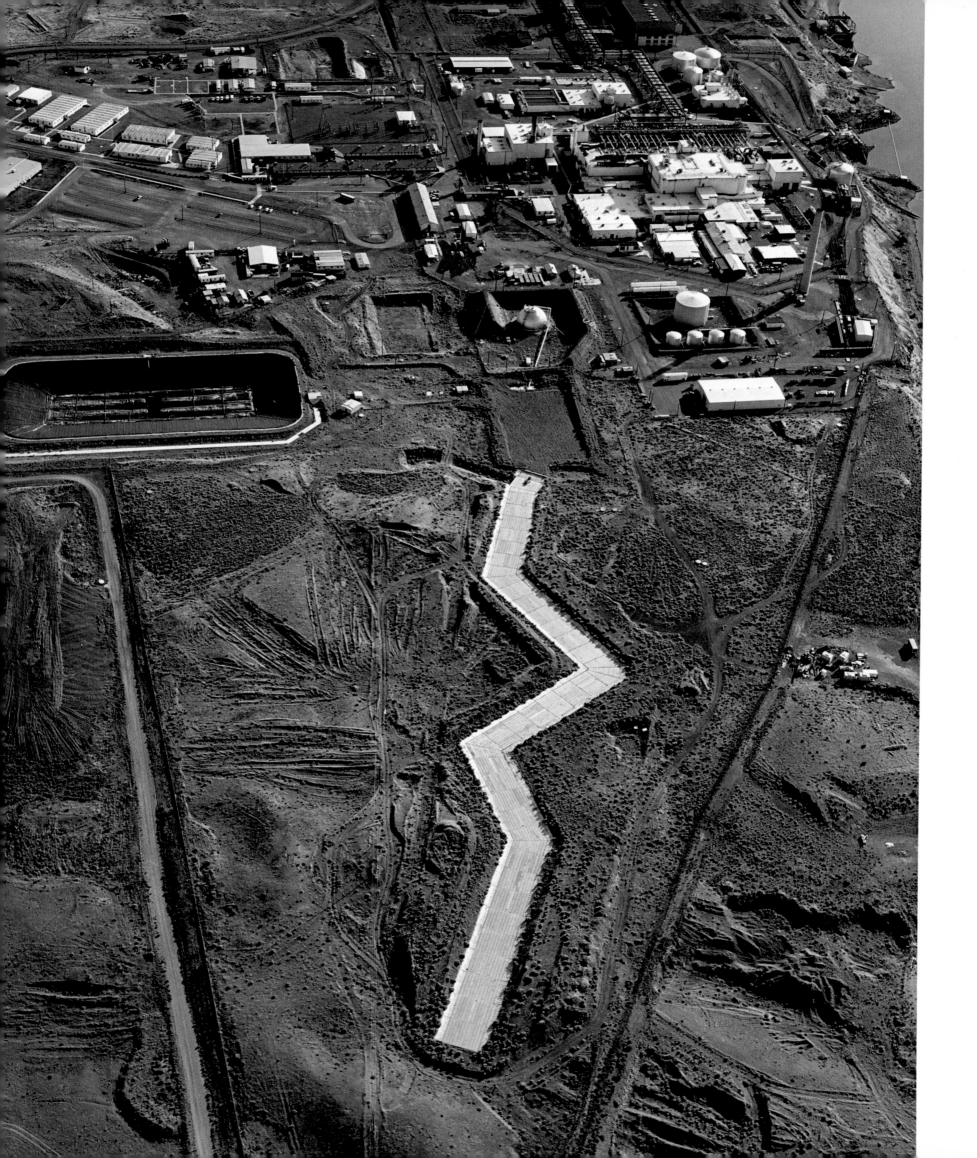

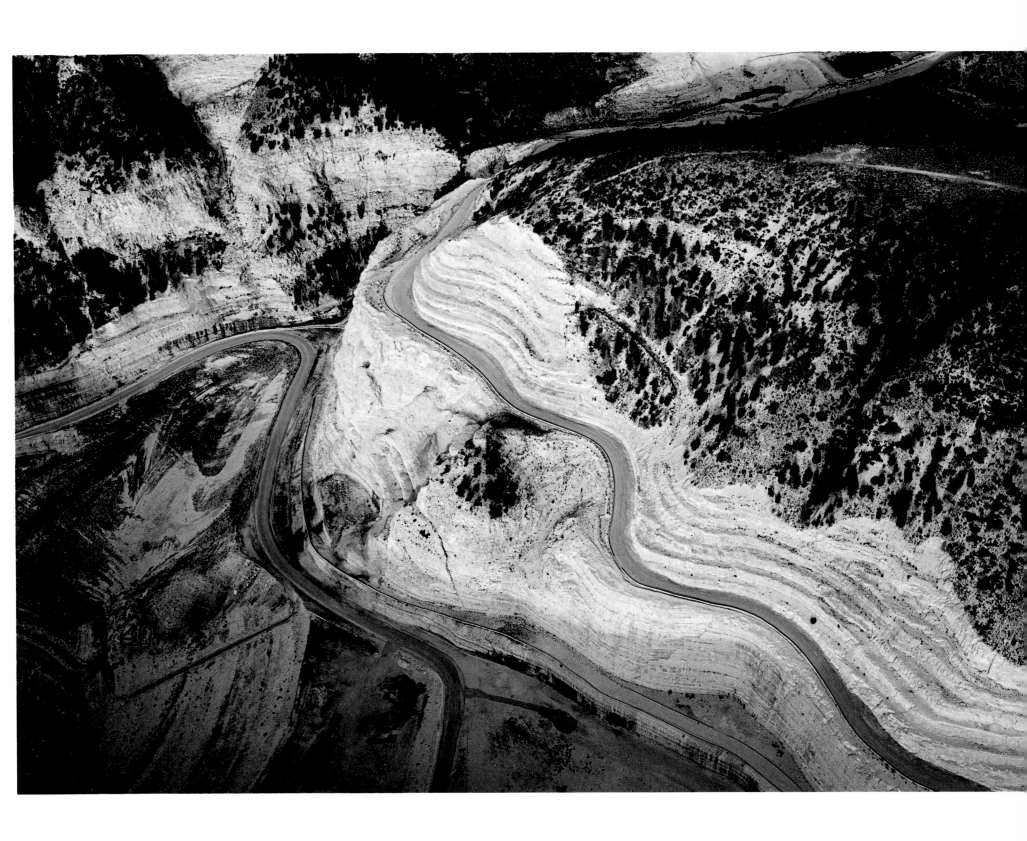

Left: *Hanford Nuclear Site Overview, Washington, 1992*

Above: *Abandoned Exxon Oil Shale Site, Parachute, Colorado, 1992*

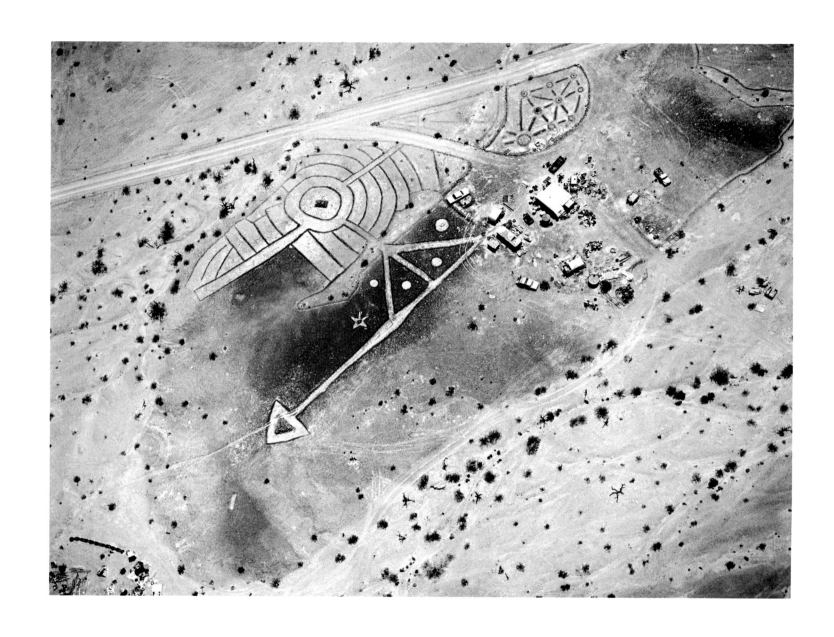

Modern Geoglyph in Desert, Imperial County, California, 1983

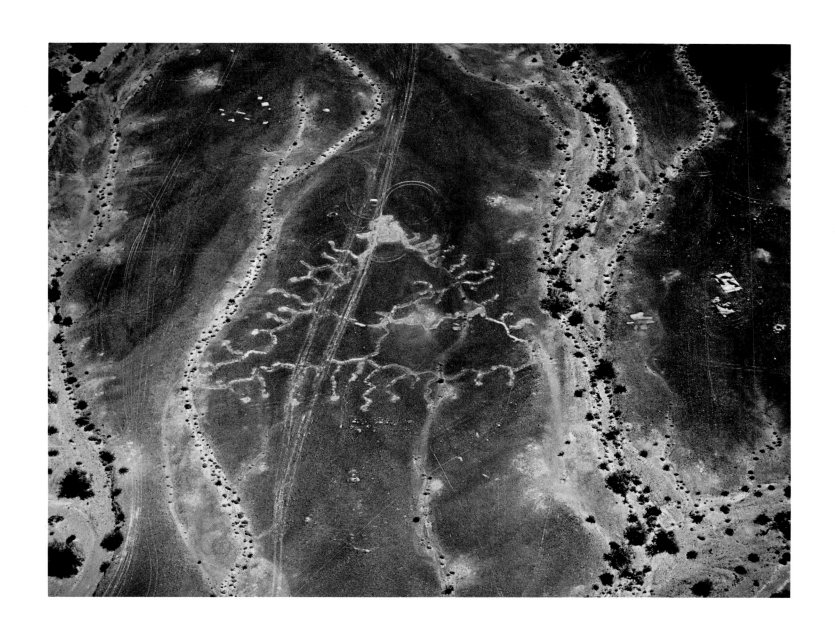

World War II Aircraft Gunnery Tracks, Imperial County, California, 1983

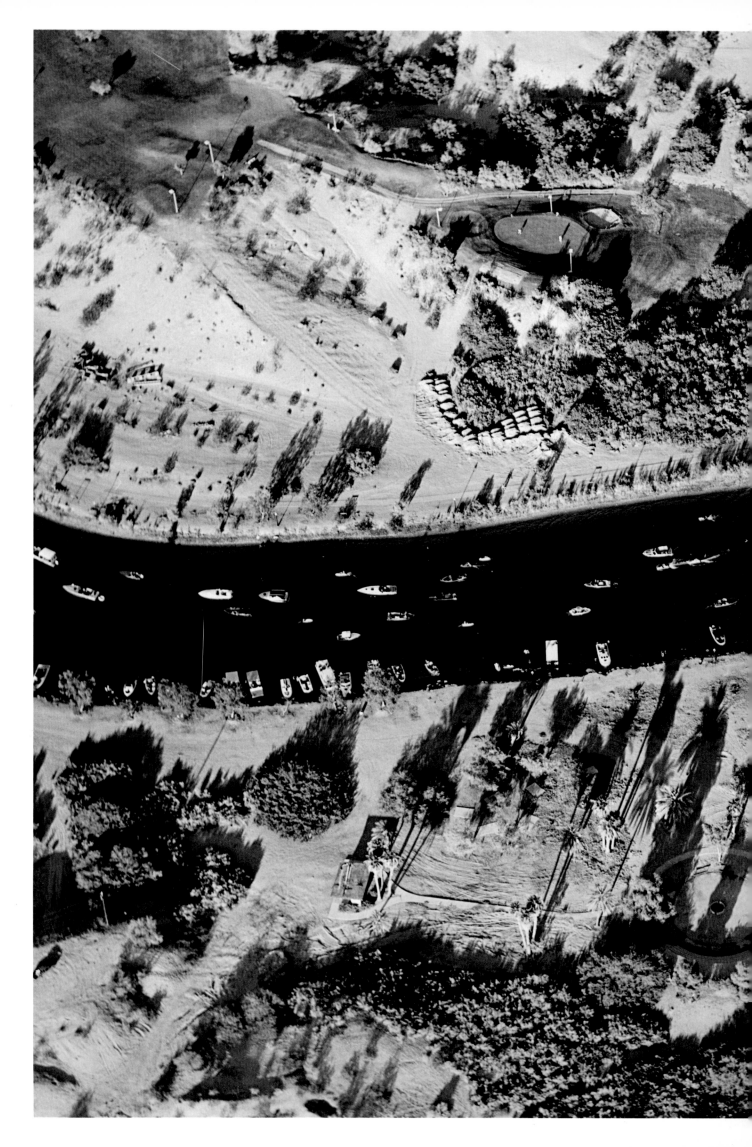

Boats on Man-Made Waterway, Lake Mead, Arizona, 1991

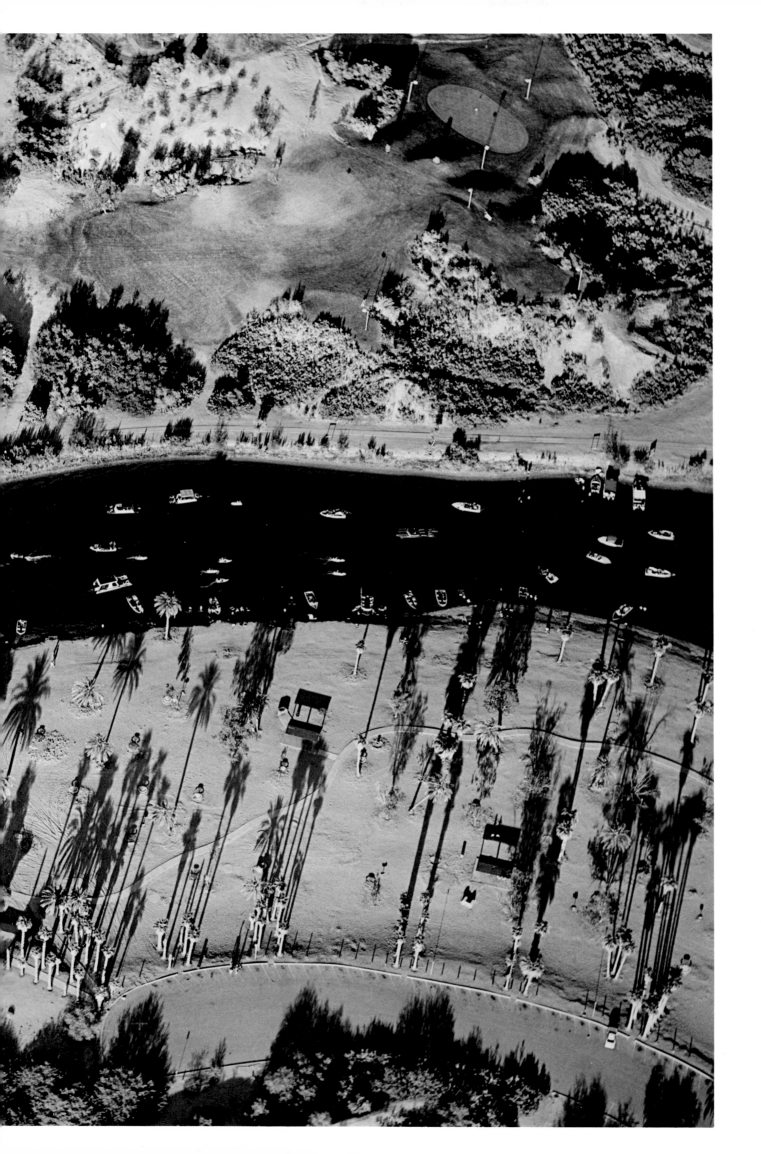

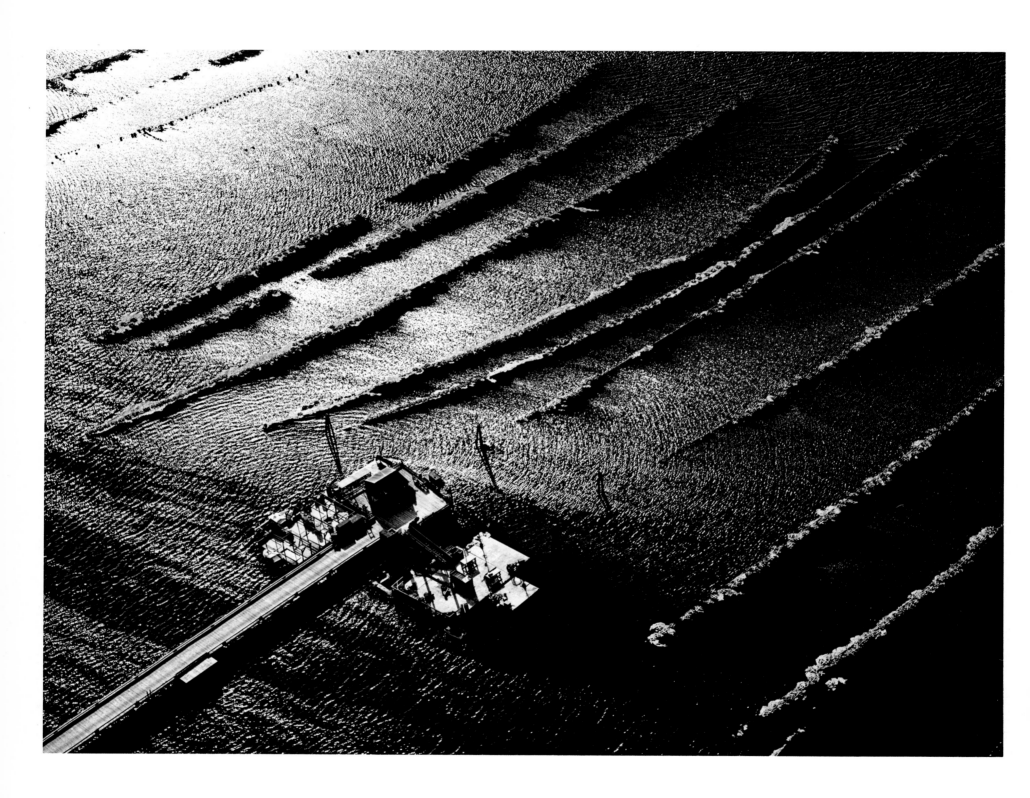

Net Fishing, Puget Sound, Washington, 1992

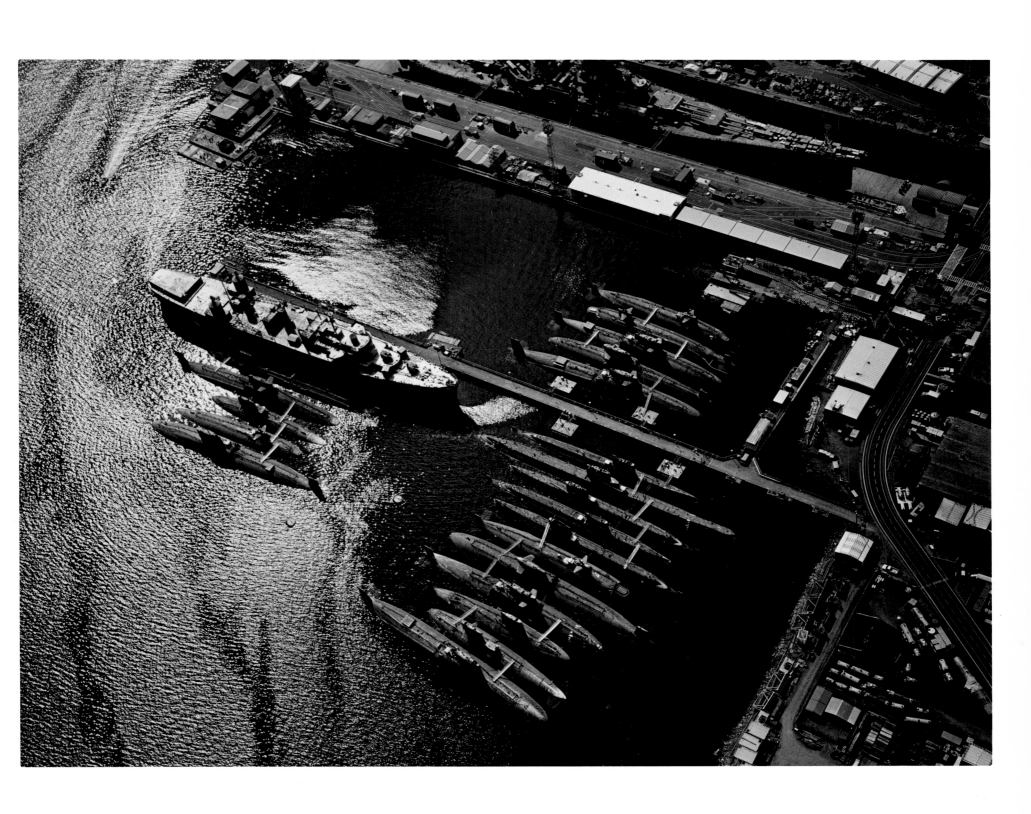

Nuclear Submarines, Washington, 1992

Housing Development Developing, Arizona, 1991

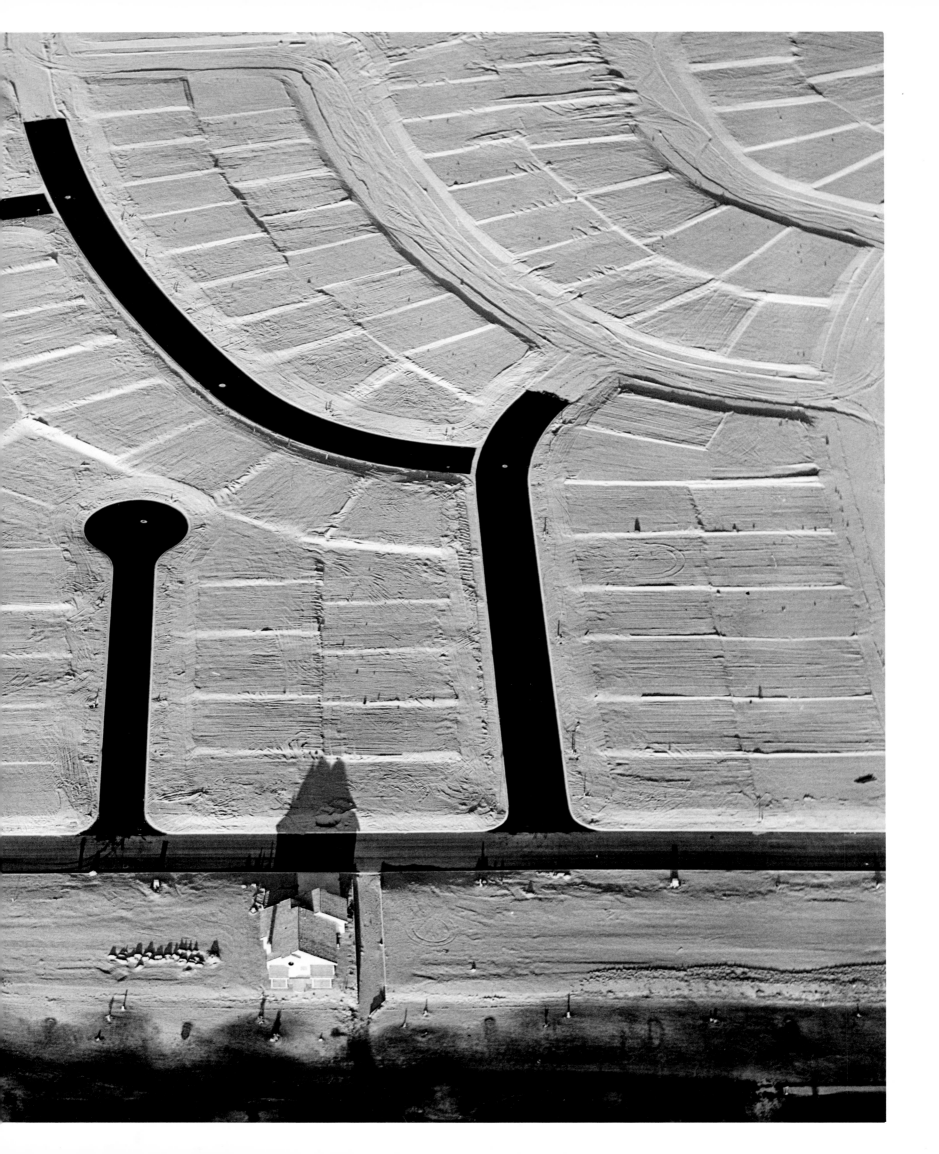

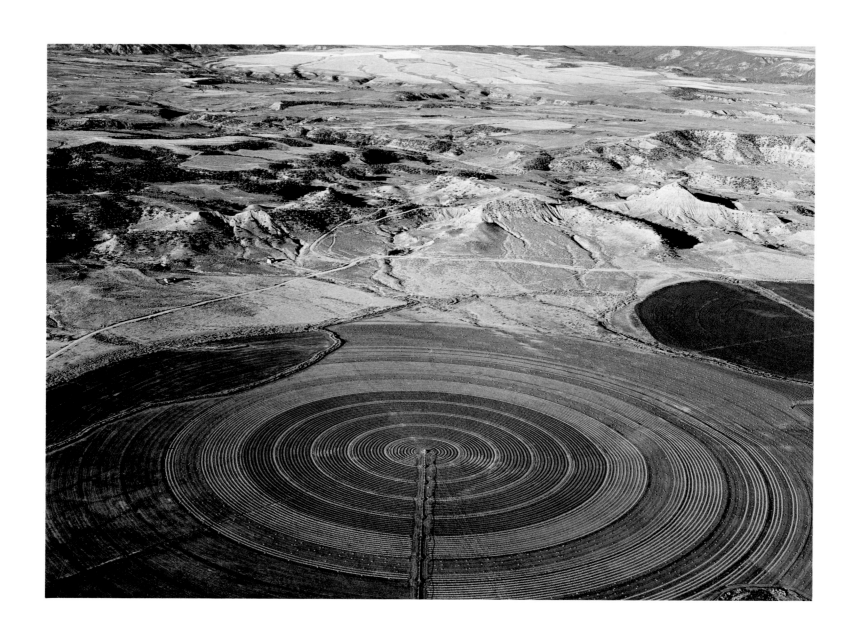

Circular Irrigation, Yakima, Washington, 1992

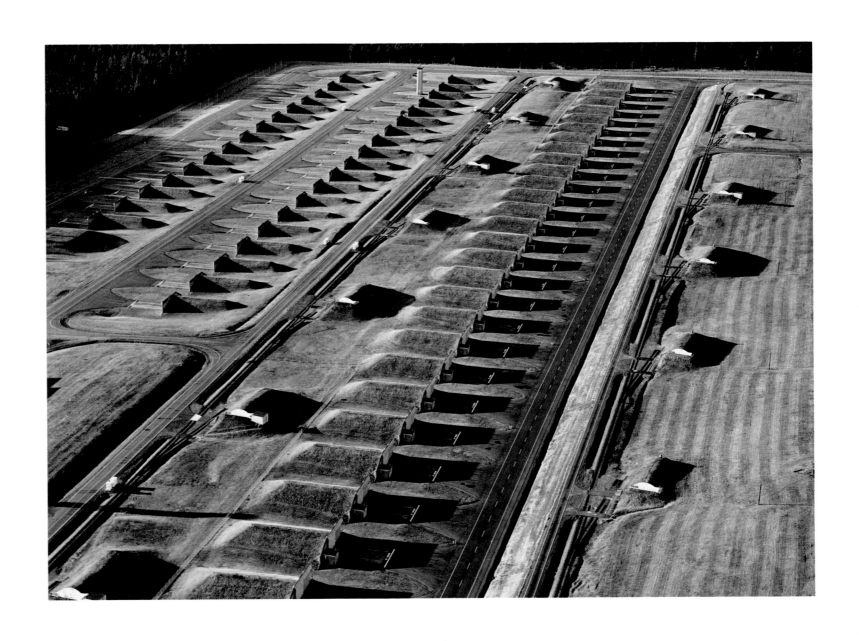

Military Installation, Washington, 1992

Desertscape, Death Valley, California, 1991

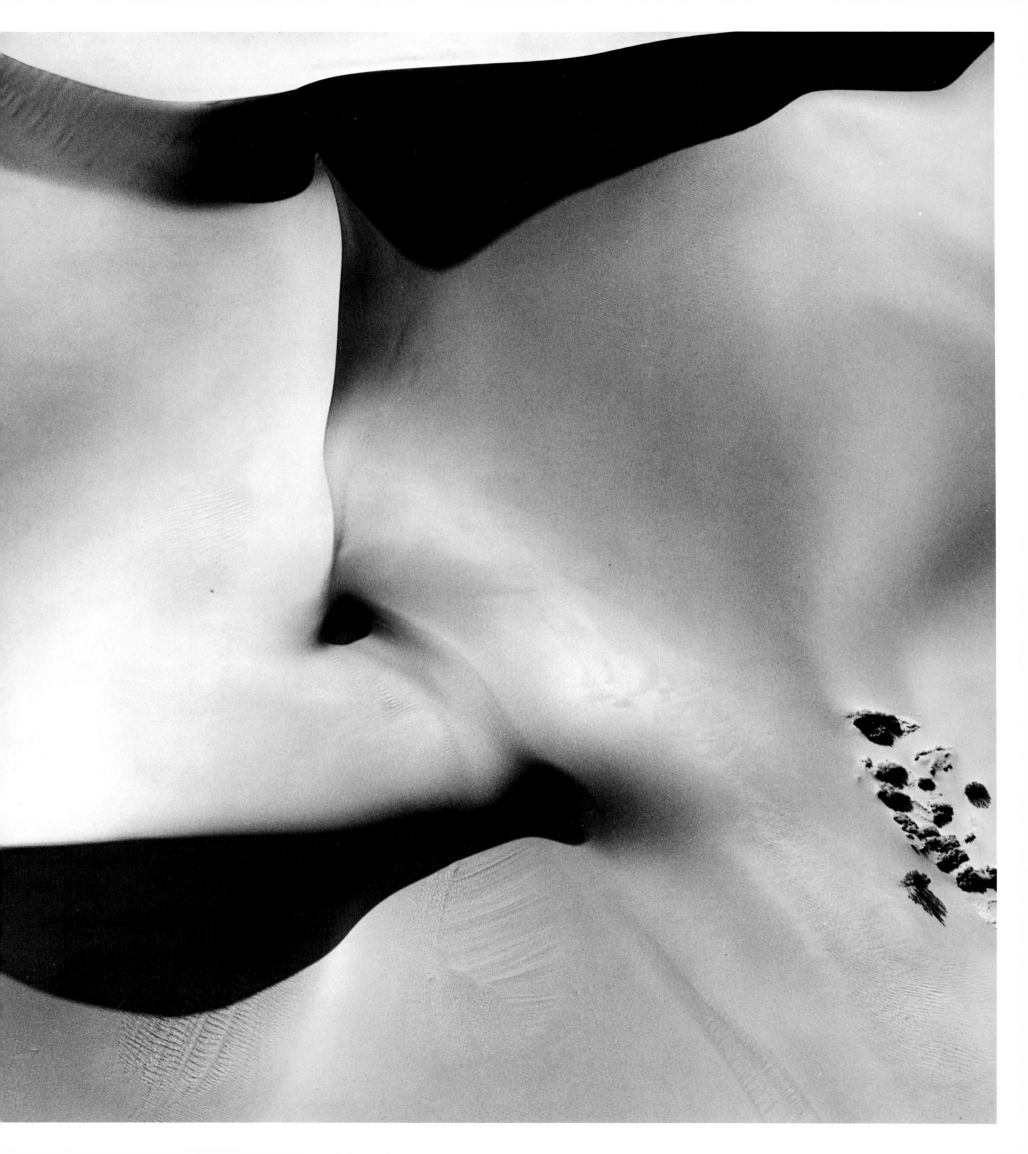

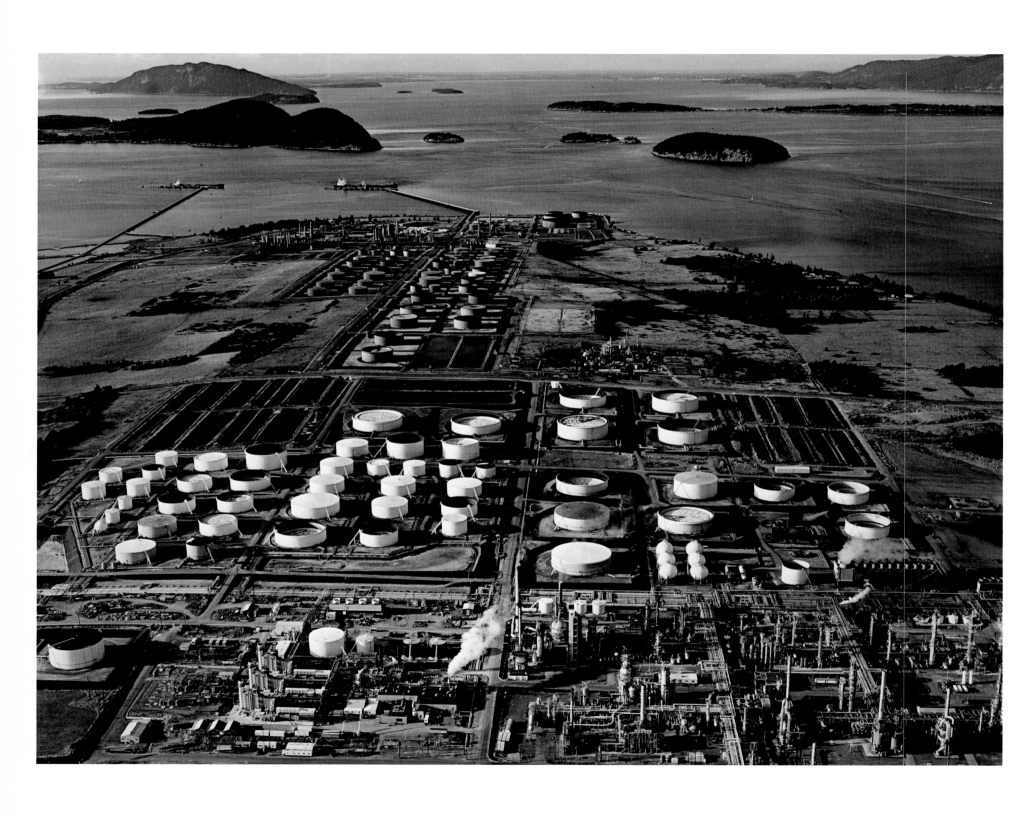

Oil Tanks, Puget Sound, Washington, 1992

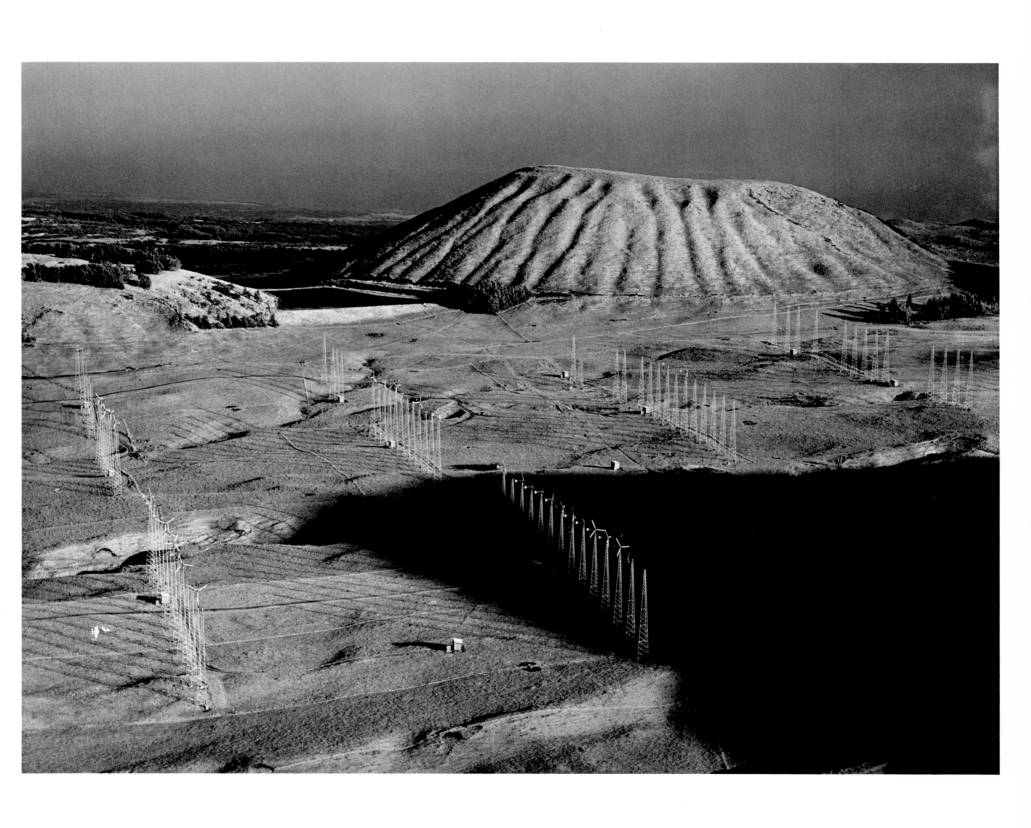

Windmills and Crater, Parker Ranch, Hawaii, 1990

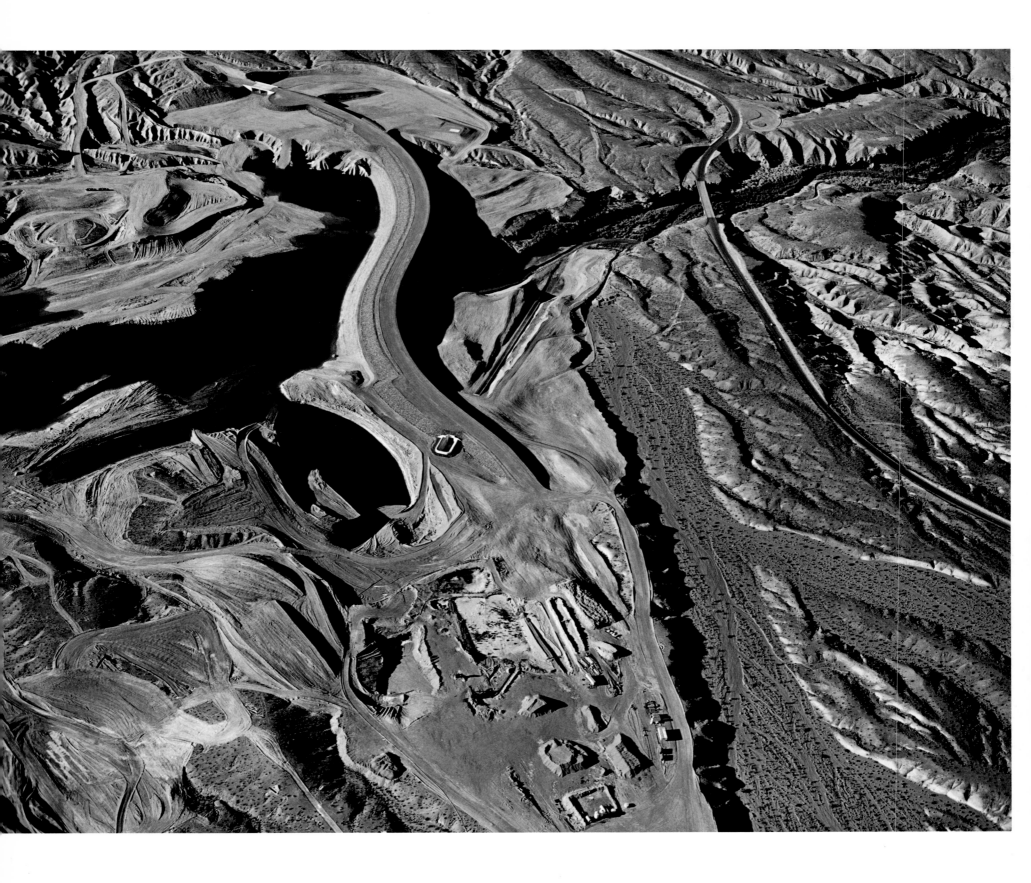

Highway Emerging, Nevada, 1990

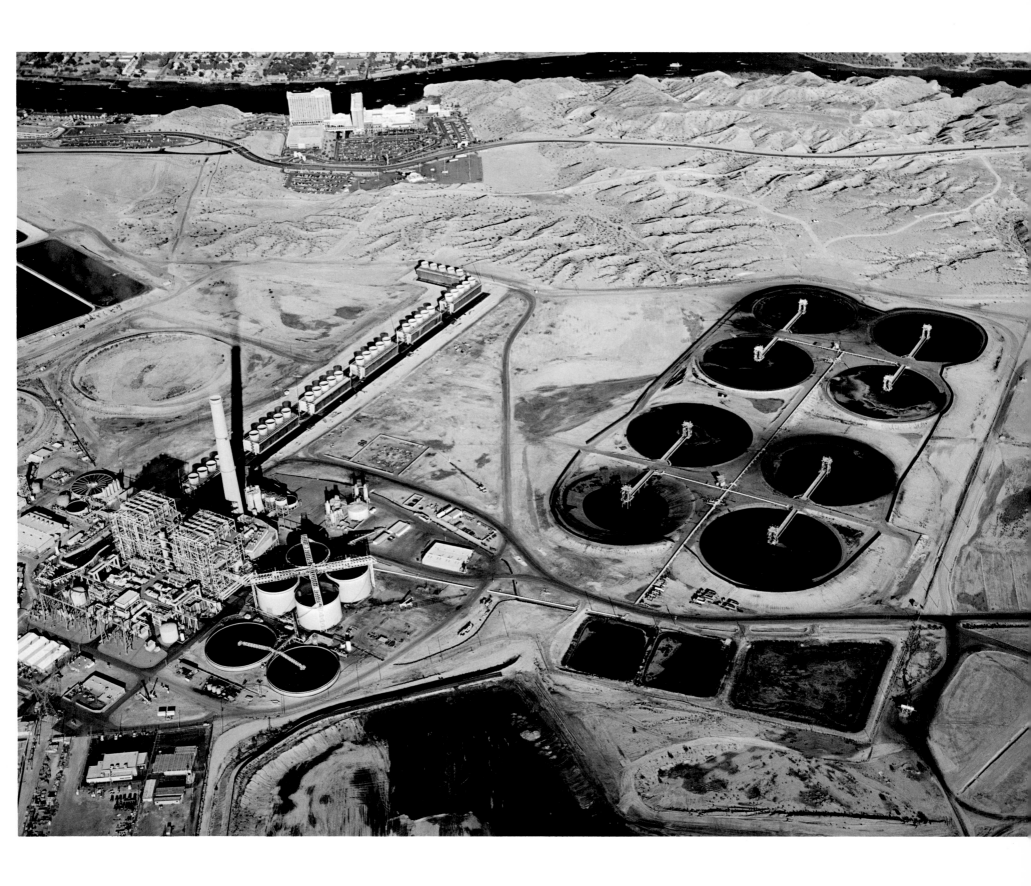

Water Purification Facility, Boulder City, Nevada, 1990

Mount St. Helens Crater with Water, Washington, 1992

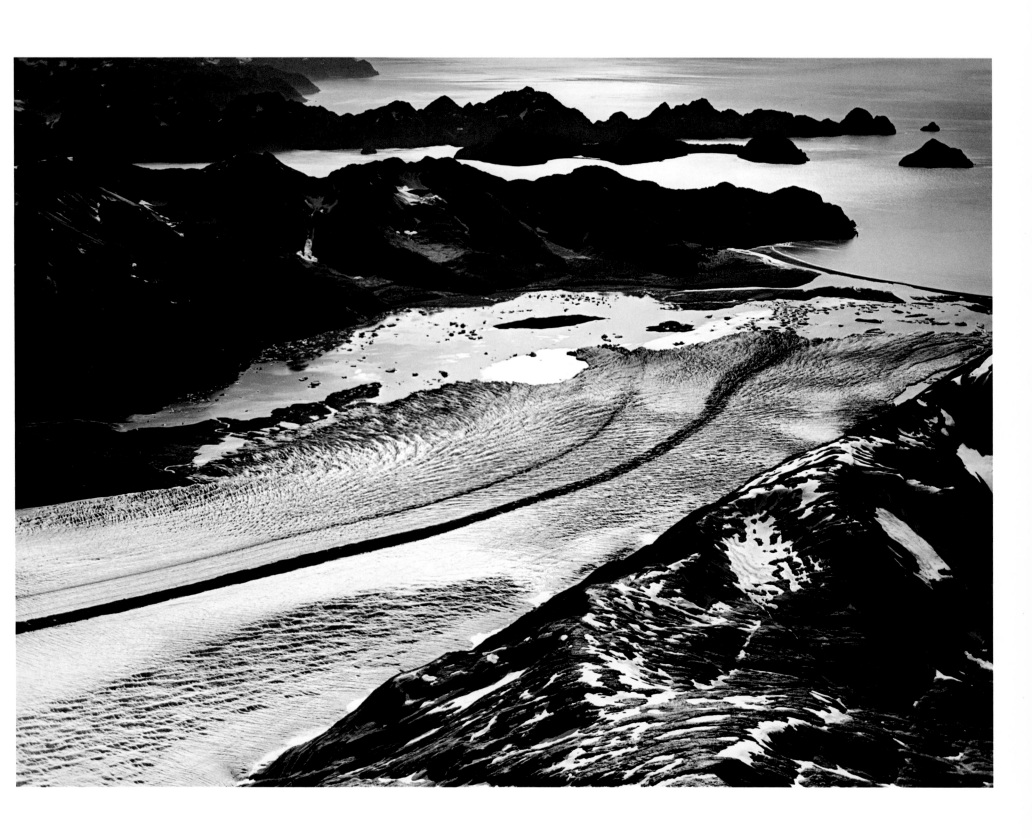

Harding Ice Field, Kenai Fjord, Alaska, 1990

Mercedes on the Edge, Monolith, California, 1991

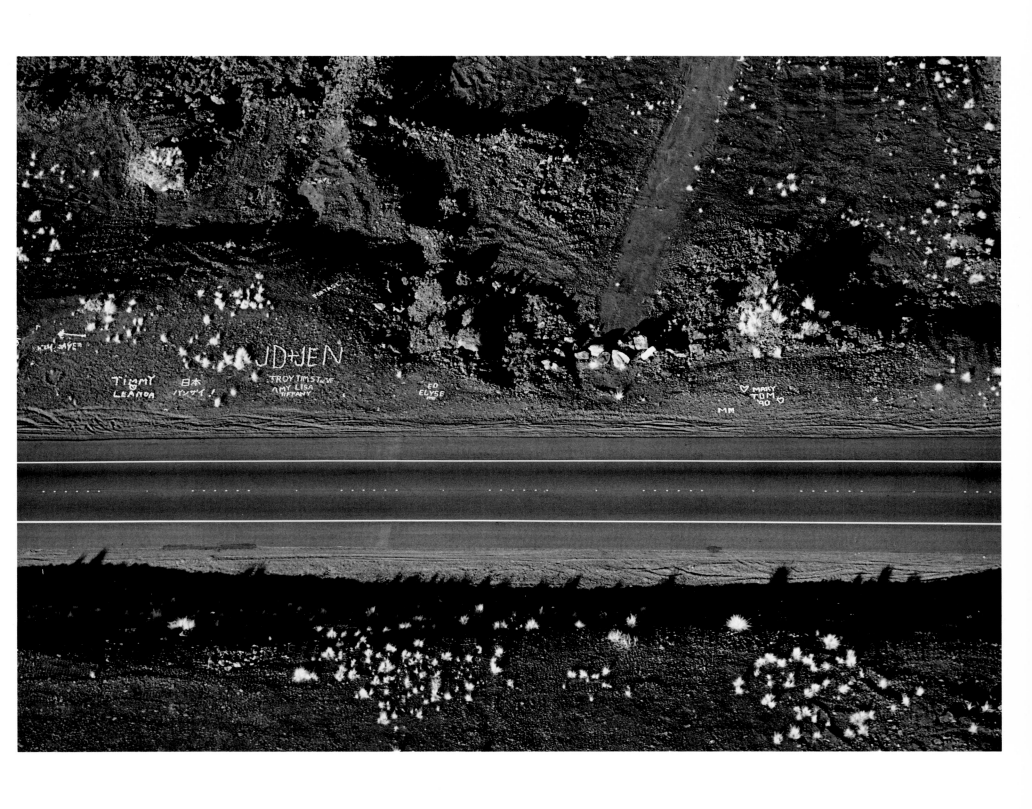

Mary Loves Tom, Coral Graffiti, Hawaii, 1990

Cattle Feeding, Parker Ranch, Hawaii, 1990

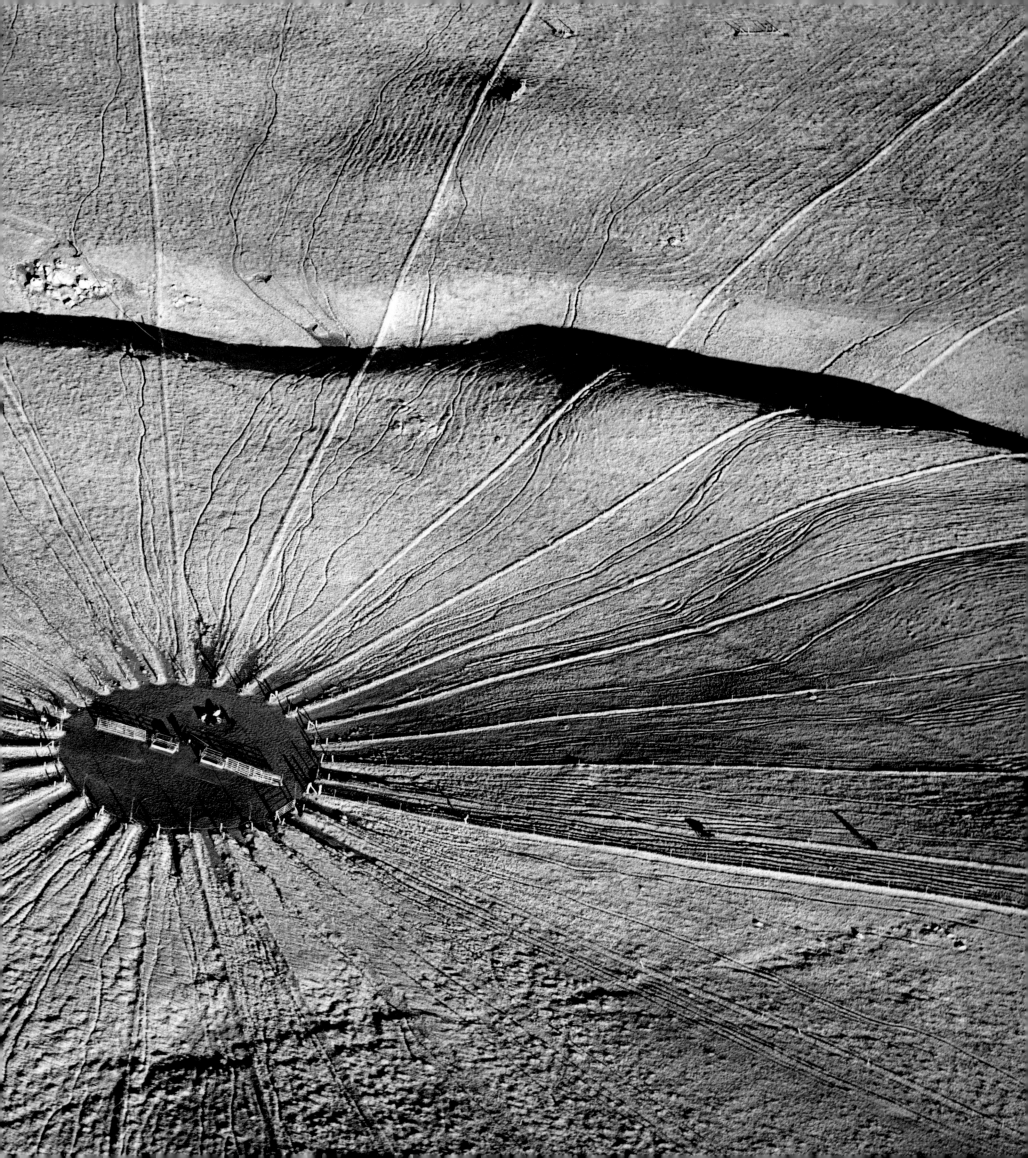

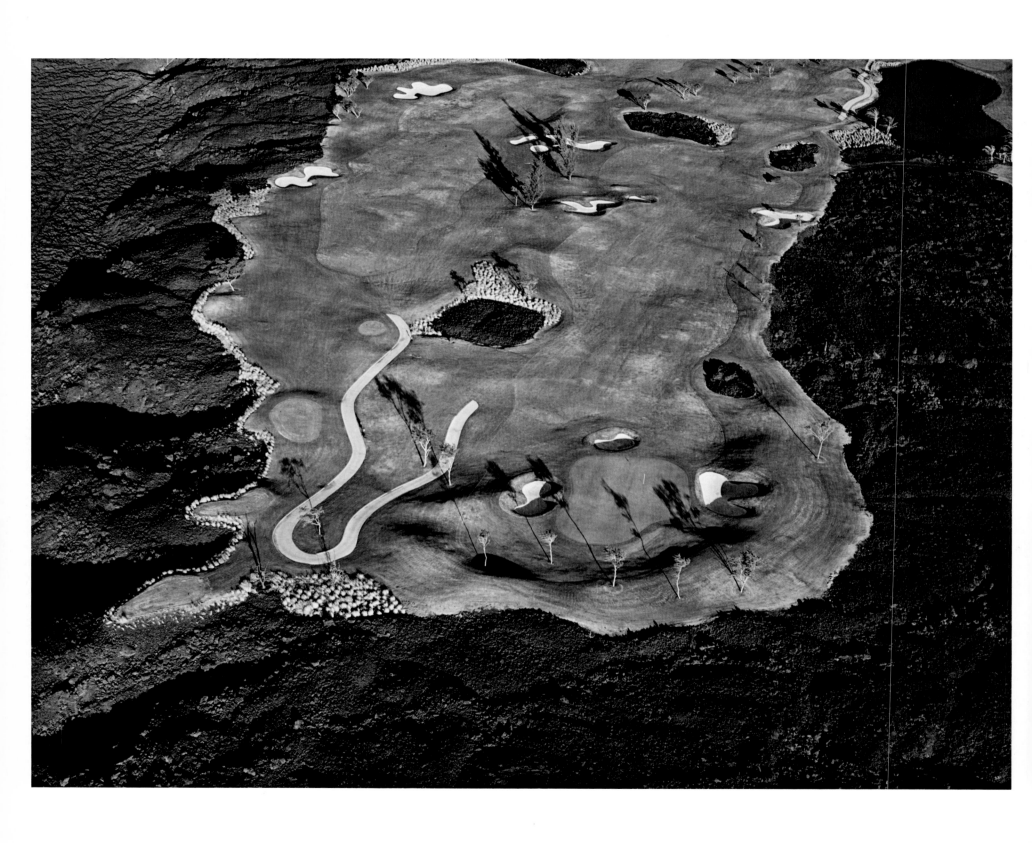

Golf Course and Lava Rock, Kona, Hawaii, 1990

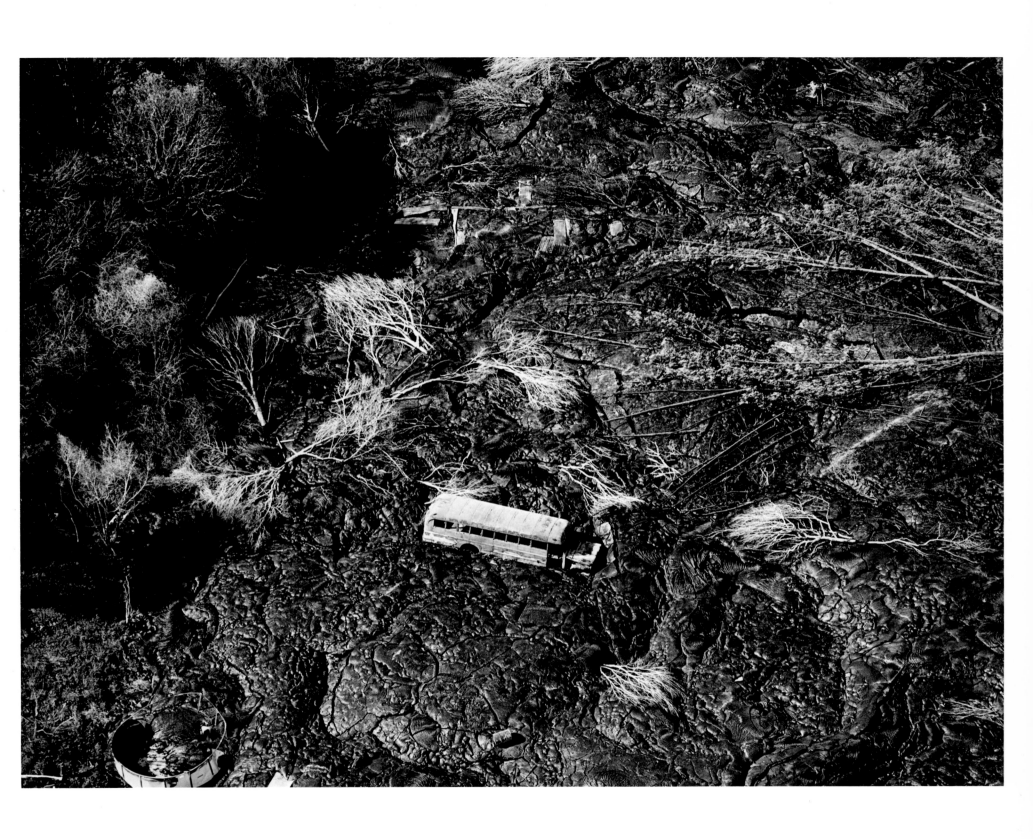

Bus Caught in Lava Flow, Hilo, Hawaii, 1990

AFTERWORD
by Marilyn Bridges

Flying in the early morning entails going from darkness into light—slowly I begin to see the landscape revealed before my eyes. Because the sun is at such an extreme angle, the land is full of contour and shape. There is a point in time that lasts perhaps one-half hour, when a complete balance and harmony is set up between light and dark. The land becomes vibrant sculpture. It seems to breathe and pulsate. It dances with life. It reveals itself. It's a time when smaller objects appear as the length of their shadows exposes them. I can see an interaction between people and the earth. They may be working or playing or traveling by bus or car or bicycle or even on horseback. Sometimes they notice me overhead and salute. Animals look like silhouettes of black ink. Shadow is a great equalizer, and sometimes only gesture can reveal personality or occupation. I become anxious to record what is revealed because I know that all too soon the sun will begin to wash away the shadow as it rises overhead, and all evidence of subject will become lost. In the late afternoon, the process is reversed. As the sun goes down, balance and harmony are lost as shadows stretch into the depths of darkness.

There is something inherently spiritual, even primordial, in this ebb and flow of light and dark. This dichotomy has long intrigued me. Not the traditional notion of light and dark as metaphors for good and evil, but, rather, in the sense of clarity and obscuration. Perhaps this is why I love to shoot in black and white. It allows me to reach far into my subject matter for deeper meaning unencumbered by the distraction of color. I work with light and shadow to lift my subject from the mat of flatness and the monochromatic hue that hides individuality and substance when the earth is observed from above. It is in this drawing-out process that my subjects shed their simple identity and evoke their symbolic nature. This movement between light and dark reaches so far back into our collective consciousness that it is possible all religious faiths derive from it. The power of light and dark was the envy and dread of early humans, and it was through photographing the relics and remains of ancient peoples that I first encountered the historic presence of that power.

I began my photographic career by photographing the enigmatic Nazca Lines, the giant earth drawings and geometric shapes that form a historic calligraphy on an isolated pampa in southern Peru. These markings, which can be fully comprehended only from the sky, also gave me my first taste of aerial photography. Using a Cessna aircraft with the door removed and with a hand-held camera—which has become my standard operation—I recorded these historic sites with an enthusiasm and sense of adventure that I had never known before. I began to see the traces of humanity's tenure on the planet as a sort of code to be deciphered with my camera. This was the beginning of my quest to photograph sacred sites around the globe, which has taken me to the Yucatán to document the Maya civilization, to Greece and Egypt to trace the structural icons of those seminal civilizations, to Britain to record the megalithic remains of England's earliest people, and in the United States to call attention to the fragile and quickly disappearing earth-art and architecture of America's native people. In all of these series, the object to be photographed was a subject unto itself. The landscape was secondary to my study. But slowly over time, I began to see the land merge with my subject. I became conscious of ancient peoples' efforts to join their industry with the environment. Time might have reduced their creations to mere hints, but I could see from my heightened perspective that ancient people, from what I believe was a deep sense of spiritual relationships, integrated their creations with the land. I have said elsewhere that "man creates his models as a result of his life on the surface of the planet. They are a reflection of his relationship to the landscape. Primitive man manipulated the landscape, but an impression of harmony emerges from his attempts." I hold to this notion. I also believe that for ancient builders, "a structure did not merely sit upon the land, but arose from it, from roots deeply placed in the soil." The icons of modern man that spell our time on the planet have no such innate philosophy.

The subject of my present work is the American landscape. It might seem strange that I am only now producing a work on

my own native land. But it is not that the process of discovering it is new to me. Initially, photographing the United States was an exercise in the study of photography from the air. I was a student at Rochester Institute of Technology working on my masters degree in fine art. I had chosen as my thesis the theme "Heightened Realities, Elevated Views." The intention was to take my previous experience of shooting the Peruvian landscape from the air and apply it to my home territory. The challenge, I felt, was to make something out of nothing. In Peru, magnificent ancient ruins were everywhere. Here, as far as I could see around me from the ground, were only houses, roads, farms, and similar, commonplace sights. Soon, however, as I made my flights over grounds I thought I knew from the surface, I discovered a view virtually littered with habitation. A familiar farmhouse or playing field gained unfamiliar dimension. I realized that here too humanity's occupation of the land had developed a calligraphy, that, when read from the sky, told of our attitude toward the earth. There was disarray and lack of harmony that revealed our loss of place and isolation from our environment. Some of my early work in this country exhibits this collective disorder.

Perhaps it was my concern at this disorder that caused me to fly at lower and lower altitudes, where intimacy with the subject matter allowed me to regain a sense of the personality and individuality of place.

I discovered, at the same time, that my work was taking on autobiographical overtones. I was reaching deep within my own subconscious, where memories of my grandparents' farm haunted me. The homestead in New York's Hudson Valley had been granted to my family by the King of England in the 1600s. The tones and shadows that draped my American landscapes spoke of births and deaths, the "pixie tree" where my brothers and

I played, the small pond on which we rowed a boat, the slow selling-off of the land as big commercial farms began to overtake the family's dairy business, and finally the loss of the farm altogether, and a detachment from the land. My photographs taken at this time remain full of sadness.

It is not surprising then that upon receiving a Guggenheim Fellowship just after graduation from Rochester Institute of Technology, I jumped at the chance to document the Maya culture in Mexico. I had learned from my experience photographing the United States to identify with my subject matter, and how to intensify my emotional response to it. Now with an alien culture to document, I could bring objectivity into play. Flying over the jungles of the Yucatán, where the remains of a great civilization were hardly visible among the sea of green forest that overtook the abandoned palaces, temples, and courtyards, it became obvious that humanity's creations are tenuous at best. The Maya struggle to define place by constructing icons of their beliefs could only hold back the inevitable superiority of Nature. During these flights over often inhospitable areas, the pilot, in order

to study his charts, would sometimes turn over the controls of the aircraft to me. Untutored in even the most simple preliminaries of flying, I felt an uneasiness that bordered on terror. I lost a number of photographs because of my inability to communicate with the pilot in terms that made aerial sense. This experience (and a previous one, when a hotshot pilot, ignoring my pleas for safety and with a note of masculine bravado, nearly landed us in the ominous cone of the recently erupted Mount St. Helens) made me realize that I would have to become a pilot myself if I was to continue to photograph from the air. Not that I ever intended to pilot a plane myself while photographing. But in order to command respect from my pilots, and to know what maneuvers an airplane is capable of— even to know how to stretch the performance of an aircraft in order to achieve a positioning that extends the commonplace aerial view—it was essential that I get my pilot's license. Besides, I love to fly. To be birdlike rekindles a purity of spirit. For me it can almost be like meditation. The air is crisp, and especially in the early morning, there is a sense of calmness when one is aloft. One flows as if in a swift, unencumbered river current. Detached (at least for the moment) from crises and obligations, my spirit is recharged. It has become a necessary part of my being to be periodically airborne.

The growth of my expertise in flying coincided with the expansion of my subject matter abroad, where the focus of my attention continued to be ancient sites. But, after each project, upon my return to the States, I managed to increase my inventory of images of the contemporary landscape and the structures the builders of today spread on the surface of the land. At first I avoided subjects like industry and cities because their tortured appearance on the earth depressed me deeply. Although they might appear sculpturally sound—even enticingly photogenic from a compositional point of view—I had a deep distrust of their intrinsic worth. Instead, I sought out the great vistas of the West, where the carved earth holds a triumphant edge over the encroachment of man, where deserts remain pure because of their inhospitable disposition. Yet even there, at the fringe of these expanses, humans have dug a foothold. There was no way

of getting around it. If I was going to record America from the air, I was going to have to include its unattractive side.

It is our impact on the landscape and the imprint we leave on the surface that I am addressing with these photographs. It is certainly not all bad (as some millenarianists insist) nor all good (as harbingers of progress proclaim). It is in fact uncomfortably somewhere in between. These photographs are intended to get the viewers' attention. Artistically, I want to entice the audience with a way of looking at the earth that is not usual. By encouraging them to perceive from another perspective, I hope to alter the old steadfast view that the land is simply something we live on. I want the viewers to feel they are looking down over the edge of a precipice, and that the discomfort and disorientation they feel is part of the discovery. I want the viewer to feel something about our interaction with the land and not just intellectualize it. I want them to know that the message is rightfully emotional. In order to accentuate the pure emotional response, I almost never return to the same site to photograph a subject (unless I have failed technically the first time), because it is my first reaction to what I'm seeing that I want to incorporate in my image. (In a practical sense, it is also very difficult to reposition oneself in the same place in the sky.)

In the nineteenth century, the notion of America conjured up idealized visions of the proverbial Promised Land. People reached these shores to begin a destiny with the land. The hardships these immigrants endured were considered well-suffered for the greater good—for the sake of their children and the generations to follow. The legacy they left us we enjoyed. The legacy that people of the twentieth century have left to the twenty-first may not be so enjoyable.

It's been more than forty years since Woody Guthrie wrote "This Land Is Your Land." The song affirms the grandeur of the land as a symbol for the unlimited possibilities of a people blessed with this "land of good and plenty." But the years have not been good to the earth. Mankind has flexed its muscles and challenged the land to a test of durability. There can be no winners in this contest. For there can be no doubt that while the land will exist without people, people cannot live without the land.

Right: *Luxor Hotel, Las Vegas, Nevada, 1995*

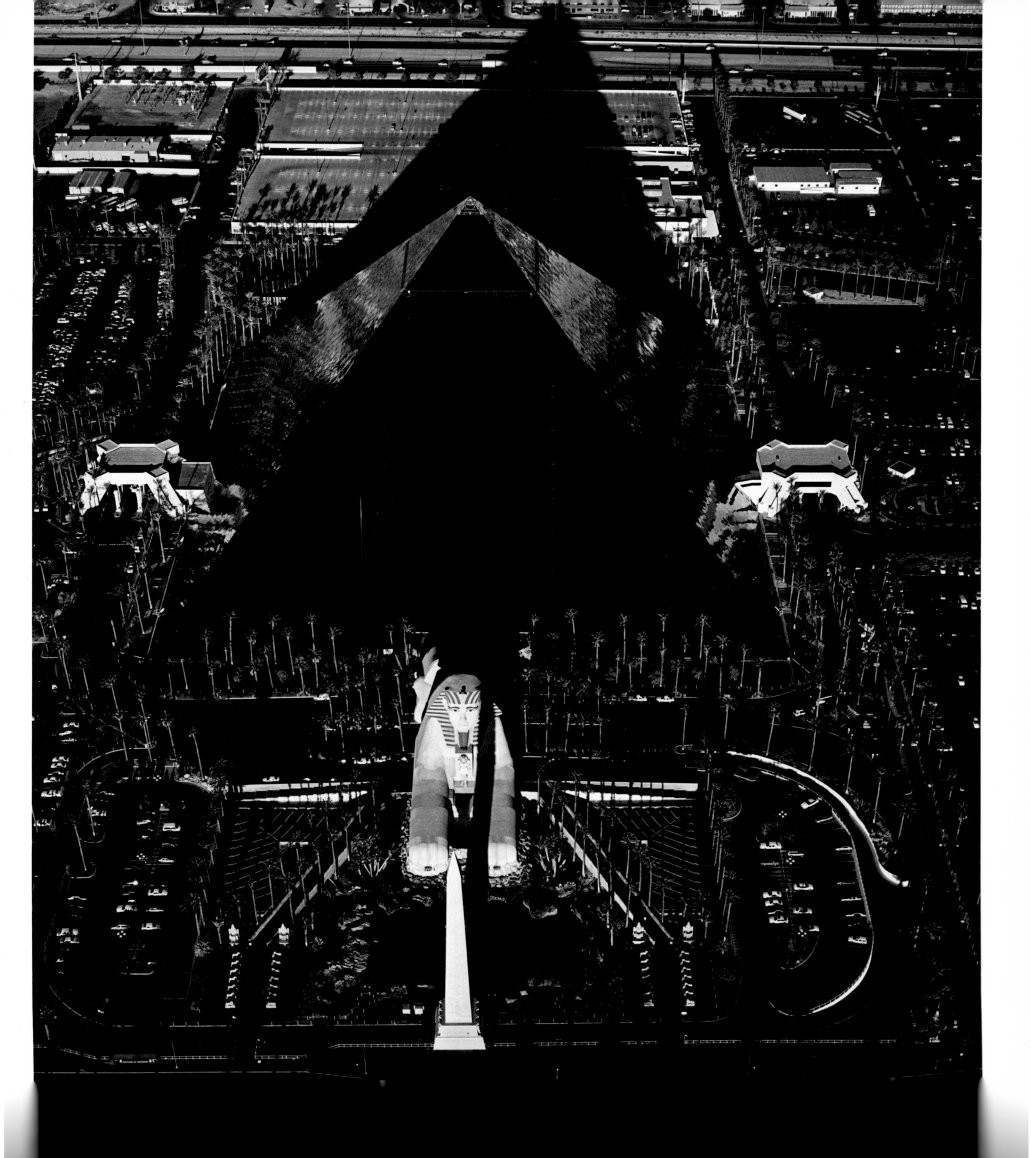